Two Women in Their Time

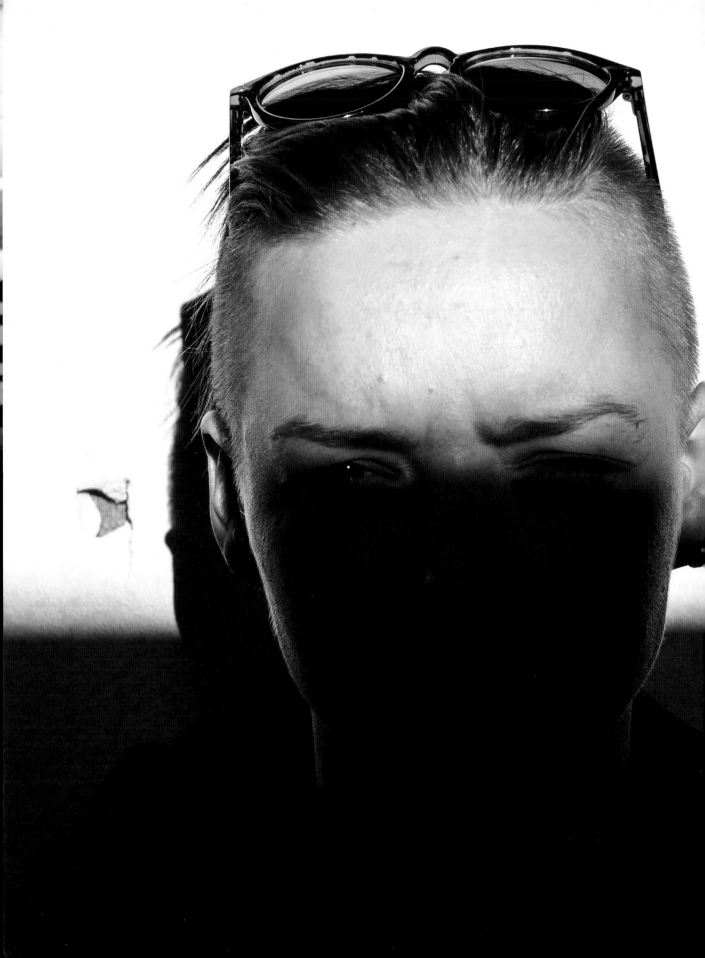

Two Women in Their Time
The Belarus Free Theatre and the Art of Resistance

Misha Friedman

with an introduction by

Masha Gessen

THE
NEW
PRESS

Requests for permission to reproduce selections from this book should be mailed to:
Permissions Department, The New Press, 120 Wall Street, 31st floor, New York, NY 10005.

Published in the United States by The New Press, New York, 2020
Distributed by Two Rivers Distribution

ISBN 978-1-62097-405-6 (pbk)
ISBN 978-1-62097-406-3 (ebook)
CIP data is available

The New Press publishes books that promote and enrich public discussion and understanding of the issues vital to our democracy and to a more equitable world. These books are made possible by the enthusiasm of our readers; the support of a committed group of donors, large and small; the collaboration of our many partners in the independent media and the not-for-profit sector; booksellers, who often hand-sell New Press books; librarians; and above all by our authors.

www.thenewpress.com

Book design and composition © 2020 by Emerson, Wajdowicz Studios (EWS)
This book was set in FF Meta, Franklin Gothic, Helvetica Neue, Helvetica Inserat, News Gothic, and Zapf Dingbats

Printed in the United States of America

10 9 8 7 6 5 4 3 2 1

Preface
JON STRYKER

This series of books was born out of conversations that I had with Jurek Wajdowicz. He is an accomplished art photographer and frequent collaborator of mine, and I am a lover of and collector of photography. I owe a great debt to Jurek and his design partner, Lisa LaRochelle, in bringing this book series to life.

Both Jurek and I have been extremely active in social justice causes—I as an activist and philanthropist and he as a creative collaborator with some of the household names in social change. Together we set out with an ambitious goal to explore and illuminate the most intimate and personal dimensions of self, still too often treated as taboo: sexual orientation and gender identity and expression. These books continue to reveal the amazing multiplicity in these core aspects of our being, played out against a vast array of distinct and varied cultures and customs from around the world.

Photography is a powerful medium for communication that can transform our understanding and awareness of the world we live in. We believe the photographs in this series will forever alter our perceptions of the arbitrary boundaries that we draw between others and ourselves and, at the same time, delight us with the broad spectrum of possibility for how we live our lives and love one another.

We are honored to have Misha Friedman as a collaborator in *Two Women in Their Time.* He and the other photographers in this ongoing series are more than craftspeople: they are communicators, translators, and facilitators of the kind of exchange that we hope will eventually allow all the world's people to live in greater harmony. ■

Jon Stryker, philanthropist, architect, and photography devotee, is the founder and board president of the Arcus Foundation, a global foundation promoting respect for diversity among peoples and in nature.

What you see is nothing.

Introduction by **Masha Gessen**

If you are a visitor to Minsk, the capital of Belarus, you see wide clean avenues and a moderate quantity of signs of life: a little traffic, a minimum of street activity, a smattering of restaurants. It's like it hasn't been over a quarter century since the Soviet Union collapsed—more like it ducked out for a smoke and is coming right back. But while no one is looking, a few things are happening—*because* no one is looking. Survival can depend on avoiding the wrong pair of eyes.

The theater, then, is located on a street that's not a street, in a building that's not a building. The street is an old stretch of countryside wedged between high-rise apartment blocks like a long-forgotten secret. The building is a garage adjacent to a private house, but it's not a garage. It has a second-floor addition with light imitation-wood flooring and skylights. The swinging garage doors, which face the street, are permanently shut. Two human-sized doors face the courtyard, which is shielded by a small fence. Both doors have sheets of typing paper tacked to them, with hand-printed signs: "We have started. Please don't knock." But the doors are open: the show hasn't started yet. Inside, it smells of potatoes cooking. This evening is the second-ever performance of a play that takes place at a dinner table.

Sveta comes back from her mother's house, the rare errand she runs without Nadya. Sveta's mom made mushroom-filled blintzes for the show tonight. She made them last time too, but there were too few—or they were too delicious—for even all the members of the cast to get a taste. This time she's made a bigger batch. Sveta gets cooking on a single-burner electric stove rigged up in what serves as the backstage in the garage. She is going to make most of a feast for about thirty people. There is zucchini—three pale skinny ones from the store and two giant ones from Sveta and Nadya's garden; Sveta proudly notes that the home-grown ones will need to be cut in half. Sveta cuts up pork chops, skin on, and uses one of the fattier pieces to grease the pan before filling it. Claire, a staff member of the theater, visiting from London, starts washing cucumbers and tomatoes. She has just finished reading a translation of tonight's play, which is based on oral histories of the Second World War collected in the Belarusian countryside. The reading, she says, left her unsatisfied: she understood the words but not why they were strung together.

The play is in Belarusian, a language wedged, linguistically and politically, between Russia and Poland. Thirty years ago it seemed on the verge of extinction; the dream of post-Soviet independence hinged on revitalizing the language, but Aleksandr Lukashenka, the retro-Soviet dictator who came to power in 1994, pushed the language back to the margins. The entire troupe belongs to a generation that grew up rarely hearing Belarusian, but all of them have made a point of learning to speak it—and at least one person tries to speak Belarusian all the time. To some extent, Russian and

Belarusian are mutually intelligible, but, as with any pair of related languages, this sometimes produces a comical effect—usually at the expense of Belarusian.

A few minutes after six, Sveta, who usually speaks Russian, starts hollering in Belarusian that someone has swiped the porkfat. A suspect is identified, then exonerated when the porkfat is found. The kitchen switches back to Russian, but every few minutes a louder and higher-pitched spat erupts in Belarusian. This is play, in the childhood sense of the word—or it seems like it. By now the actresses have changed into colorful frocks of the sort that might constitute evening wear in the countryside, and applied garish makeup. The male actors are still wearing shorts and t-shirts, but by twenty minutes after six one of them is getting reprimanded for calling an actress by her real name. By half past six the men have changed too, into shirts and trousers that fit a little too well to be Belarusian-countryside but look a little too bland to be Gosha Kupchinsky creations.

Shortly before seven, Nadya and a couple of actors saunter over to the nearest supermarket to meet up with the audience. To see a Belarus Free Theatre production, one has to show up in front of the supermarket. To know to come to this meeting spot, one has to call a cell-phone number to make a reservation and get directions; most of the time, it is Nadya who answers. To know to call the number, of course, one has to be in the word-of-mouth universe of the theater. The audience is a slowly expanding closed circle, and its insularity is its insurance policy against the wrong pair of eyes.

• •

It's a small crowd in front of the supermarket. Several people are regulars, but you can tell the ones who aren't by how hard they are trying to put on a brave face. They look at the actors, in their brown polyester pants tucked into rubber ankle boots, and ask what's happening. In-between spitting out sunflower seed shucks, the actors say something about a birthday party. This does not put the newbies at ease, because it explains nothing.

In the garage, things are nothing like a garage—nor like a theater. It's a post-Soviet livingroom/diningroom space, with scuffed formerly polished-wood cupboards and a long table composed of many shorter ones, looking like it may cave under the weight of food and drink. It will take some sleight of hand for the actors to keep pouring real vodka for the audience while they pour themselves water from the barely-perceptibly marked bottles. There is drinking, and eating, and talking, and drinking, and talking, and eating. The actors reminisce about the Second World War. They start slow and predictable—their stories fall within the official narrative of the heroic resistance of the Belarusian people—and gradually they begin to veer off the expected ››

path. One woman says that the Germans, who occupied her village and her house, treated her kindly. A man says that he didn't have the courage to join the partisans and anyway the whole heroic narrative is overblown. The actors are much too young to remember the war—they are reciting the words of people who could be their grandparents—and this helps the audience understand that, though they are sitting at the table and eating, they are also watching a play. The actors keep helping them fill their plates and their glasses as they take them through a range of emotions from mocking laughter to hysterical screaming and stomping in and out of the room—so that by the end of the second hour all bets are off.

It is then, during a pause in the dinner conversation, that Kirill says, "That's who we are. We are still doing what we do best: being scared." Kirill is one of the younger, newer members of the troupe. He has a beard and is wearing skinny jeans; plus, he is speaking Russian. The audience thinks that he is one of them, and the dam breaks. One of two women who have looked nervous and uncomfortable ever since they were picked up in front of the supermarket two hours ago now starts explaining why she decided not to go to the protests back when there were protests but says that next time she will. Another audience member says, "We here are the children of those who didn't speak up. They are the ones who survived." Even though there seems to be general agreement among the audience—the heroic narrative has been debunked, everyone can own their cowardice—the conversation devolves into something like a fight, perhaps because this shared understanding is so unsettling. There is shouting. Kirill stomps out. It's all in the tenor of the play, so the shouting and the stomping seem almost ordinary.

One of the actors, still in character, starts playing the accordion. Everyone sings along. People dance. After the dancing, the audience is confused. Is it over? Kirill has quietly returned. A man and a woman get up to leave. Then there is a toast: "Long live Belarus!"—because it's in Belarusian, this is an oppositional sort of call. Everyone stands up and clinks glasses and then drinks, and then everyone sits back down: it seems the show will go on—or will it? Will it go on all night? softly asks the woman who is now sitting back down.

Ragged endings are a specialty of Belarus Free Theatre. Whether on tour at one of the big theaters they play elsewhere in the world or here in the converted garage, they blur the line between the play and the reaction to the play even more insistently than they cross the boundary between the audience and the actors. They often interrupt a show a bit more than halfway through, imitating an ending only to return to the production, which the audience now sees with different optics. Today, the play seems to be slowly fading. The actors are getting up, filling mason jars with leftovers. The single

conversation breaks into several. There is still the accordion, a bit of singing, some melancholy dancing. The couple who got up earlier finally leave, looking relieved.

• •

It's a long drive home for Sveta and Nadya every night, but there is a reason they do it: space. They will wake up to a horizon broken only by some low hills and a grove a few hundred yards away. You'd think there are no other people here, in farmland. »

The house is simple: two large square rooms and a small kitchen and bathroom on the first floor and a vast refurbished attic, turned into a loft-like bedroom with a round window over the bed. There is just enough furniture: a double bed upstairs, another, plus a keyboard, in the guest bedroom on the first floor, and a round pine table with four chairs in the main space. There is a turntable and two dozen records, and a few books on the windowsill, including a Russian-English two-way dictionary and several Virginia Woolfs in English. This is aspirational reading for both Sveta and Nadya, but they have tried.

There are wood-burning stoves in every room, but on this cold midsummer day Sveta and Nadya are too tired to fire them up. Cuddling will keep them warm until morning. Their giant striped cat named Shmel' ("Bumblebee") might keep them company.

Sveta and Nadya met in August 2010. It wasn't exactly auspicious. Nadya had a girlfriend, or had had a girlfriend—they had gone on vacation to Greece together and had had the bad sense to break up on the way there. Now they were back in Minsk, no longer lovers, perhaps not yet friends, and the ex dragged Nadya along to meet a woman who'd advertised for camping companions. It was Sveta. Sveta had a girlfriend. It was complicated, which seemed like a good idea to Nadya: she'd have a relationship of enforced levity.

Sveta's girlfriend was away, and they waited for her together. They waited for their end, which didn't come, because the girlfriend sent news that she wasn't coming back. Things grew slightly confusing. How were they to maintain the levity if it was just the two of them and they were inseparable? Nadya started seeing another girl. Sveta was not too enthusiastic about that.

And there was the theater. Nadya felt self-conscious, even ashamed. She grew up in a bedroom suburb (in Minsk that's high-rise apartment blocks, not separate houses, like in the West, but the atomized, alienated sense is just the same), and she felt embarrassed that she didn't know what kinds of things existed in her own city. Nadya had graduated from university a couple of months before she met Sveta. She had a degree in economics, and a job, of sorts, that she'd been doing for two years. She ››

wrote term papers and take-home exams for other students. It was, as she thought of it, seasonal work. Nothing shameful about the work itself, though: anybody who was attending a Belarusian university was doing so only for the purpose of getting a piece of paper, as Nadya herself had done. The education itself was worthless, so she wasn't cheating anyone out of anything.

Nadya's mom, though, worried about this work thing—again, not for reasons of morality so much as reasons of convention. People were supposed to have jobs. Also, girls were supposed to have boyfriends. Nadya didn't, and this made her mother suspicious. She seemed to have as good a sense of Nadya's sexuality as Nadya herself did. The morning Nadya finally kissed a girl, after walking around Minsk with her all night—that morning Nadya came home and her mother asked her, "Have you fallen in love with that girl or something?" Nadya said no, she wasn't attracted to anyone—this had been true until maybe a month or a week or an hour ago. That was September of Nadya's second year at university. Between that time and the day she met Sveta, she'd had three girlfriends, had said "yes" the second time her mother asked her a direct question, had come out to her sister too, and had tacitly conspired with her mother and sister to hide her sexuality from her grandmother and most of the rest of the world. It's not hard, and anyway, her mother was much more concerned with the employment situation.

Sveta, on the other hand, had a job: she worked as a marketing rep for her sister's translation company. It was tedious and stressful work, but Sveta also had a passion: the theater, which had no money to pay her for helping out with stage management, lighting, and logistics. The theater was in a little house then, and it had a community, a sense of drive, and a palpable feeling of danger about it. Like it all might come crashing down sometime soon. Perhaps sometime very soon.

While Sveta and Nadya were falling in love, Belarus was getting ready for a presidential election. Not really: Lukashenka, who had been in power since Sveta and Nadya were in preschool, was going to claim victory no matter what, but he was still going through the motions, and there were people running against him, pretending against hope that they had a chance. Former diplomat Andrej Sannikau was the most visible of these candidates, and then, in September 2010, his press secretary was found hanged. And then hope was replaced with the sense that there was nothing left to lose. On December 19, Lukashenka claimed 80 percent of the vote. People took to the streets. Sveta and Nadya came. Nadya heard Natasha, one of the leaders of the theater, speak from the podium, and she knew.

It was dark. One of the other people from the theater, the stage manager, said that they should leave. They walked away. Soon after, the protesters were beaten

and many were arrested, including Sannikau and six other unsuccessful presidential candidates. Sannikau wouldn't be released for more than two years, and would then have to go into exile.

The theater, meanwhile, went on tour to New York. Everyone knew it wouldn't be the same after. When the tour was over, Natasha and her partner Kolya, who ran the theater together and directed most of the productions, and Volodya, who wrote most of the plays, and his partner Oleg, one of the actors, and Yaro, the stage manager, decided that they weren't coming back. That is, they decided that it made more sense to go into exile than to go to prison, which is what would have happened if they'd returned. The troupe came back, and it turned out that it was now Sveta's job to manage the theater. Kolya and Natasha and Volodya would still be doing the writing and directing, but managing the stage, the space, the rehearsal and tour schedule, the recruitment of student actors, the money, and everything else, including hiding the theater from the authorities, now fell to Sveta. At least she didn't have to work for her sister's translation company anymore.

Nadya helped out, because she was in love—with Sveta and with the theater: she was aware that it was both. She collected receipts, pitched in with some accounting. Then the theater was on tour in Poland with a production that was too large to show in Belarus. By that time they had already established this dichotomy: the theater was winning prizes and commissions abroad, and this meant larger spaces there than a little house or, as it was for a while, no house at all in Belarus. Abroad, they grew more and more ambitious with stage design and choreography. They learned to comandeer space. A new show involved a bicycle being ridden on stage. Nadya wanted to see the show and bought a train ticket to Poland. Somehow, when she got there and saw the troupe, it felt like coming home. When the theater was headed back—most of the actors to Belarus, Kolya and Natasha to London, where they now lived—Kolya handed an envelope full of money to Nadya. It seemed she was now keeping the books for the Belarus Free Theatre. Not exactly the regular job her mother had hoped for, but the family Nadya had sought, even if she hadn't known it.

• •

Sveta always drives. She chops the wood, too, cooks on the grill outside, does the morning inspection of the grounds and the vegetables, does a quick run to a farm down the hill to pick some late-harvest strawberries and chat up the farmers, transplants from war-ravaged Russian Caucasus. Nadya's are the tasks that require less motion and more concentration: the accounting and the holding of hands and, sometimes, heads lain on her chest by actors in distress. ››

They head back into town following a late breakfast. In short order, the garage is transformed. The Soviet-bourgeois furniture from yesterday has been, miraculously, shoved into the kitchen. Theater seating has been assembled. There are four rows formed by padded bench seats:

> In row 1, the seats are laid on the ground.
> In row 2, the seats are set on coaster wheels.
> In row 3, the seats are laid atop rectangular stools laid on their sides.
> In row 4, round Ikea stools are set upright, and the bench seats laid on top of them, like bridges.

Tonight is the premiere of a play written and directed on the premises: Kolya and Natasha supervised; Marina, one of the longest-working actresses, directed. She is a wreck. She can't hide her impatience with an actor who keeps struggling with a single line: "I am a Soviet person, there is no hope for me." She wants him to slow down, make the hopelessness a discovery. To him, though, the "Soviet" and the "hopeless" seem to go together so logically that he keeps blurting the line out as though it were obvious, and nonessential. He sees that his problem is with the ability to grasp. "I have a deficit in the brain," he jokes. "A shortage, Soviet-style." He is impervious to both Marina's irritation and her wishes.

Sveta is in the corner, managing the music on a MacBook Pro. There are two speakers on the back wall, behind where the audience will sit. After the rehearsal, she sorts photographs with Dasha, a young androgynous cast member who took these a year and a half ago as part of a protest action for the rights of disabled people. The pictures, showing people with various disabilities in intimately ordinary living situations, were projected onto a number of buildings in Minsk as part of the action. They had captions like "People with disabilities make love too," and the action was an unsubtle intervention: the projection aimed at people's windows. This kind of activism is theater too, and the Belarus Free Theatre ventures out into the city for these sorts of shows at least a couple of times a year. Many of the interventions have ended in troupe members' being detained by police for hours or days. Now the photographs will be part of this production, and later in the year the theater will start projecting them onto nearby buildings. Now, in mid-summer, it wouldn't be practical because the sun doesn't set until after the play is over. Sveta is unhappy with the way Dasha has cropped the pictures.

Less than an hour before the show is scheduled to begin, Sveta reviews the music and readjusts the set. The lighting consists of two projectors and a desk lamp and LED coil that the actors operate themselves, switching back and forth during dialogue.

Sveta doesn't like that the desk-lamp cord is visible—she loops it behind a radiator and drafts Lyosha, a lanky young actor, to duct-tape it.

Stasya, a tall, muscular actress, starts vacuuming, having been gently manipulated by Sveta. This happens to be right after the daily ice-cream run, which occurs at an indeterminate time in the late afternoon; the destination is the supermarket in front of which they will shortly be picking up the audience. Stasya holds the upright vacuum in one hand and an ice cream in the other and eats and cleans at the same time. Sveta is recropping photos, ice cream in one hand. Now Dasha, who did the ice-cream run, starts washing the floor briskly, rag mop in one hand and ice cream in the other. Dasha goes on stage—which is to say, on the floor she is mopping—in forty minutes. A large fan has been turned on to ensure the floor dries in time.

Elsewhere, an actress named Masha is paying the theater's rent: it is delivered in the form of cash in an envelope to the house next door, the one to which the theater building could serve as a garage. Kirill is doing breathing exercises. Nadya is upstairs at the computer. One after another, actresses are coming up to give her backrubs. She says that Dasha is the best.

A group goes to the corner to pick up the audience. Only one person today is new, and he is the French ambassador. At five minutes to six the house is full. A couple of extra seats are rigged up in the far back corners. Sveta cracks jokes about opening up the orchestra pit.

At six Sveta stands center-stage with a green laptop. This is where Kolya and Natasha live for most of the troupe most of the time. They rehearse by Skype, they teach by Skype—the theater is also a school, with a new crop of students every year and a half; some will stay with the theater for years. Before this premiere, Kolya will address the audience by Skype. Sveta flips the laptop around. Kolya is wearing a red t-shirt. He tells the audience that the show they are about to see has been in the works for seven years. Three of the creators of the play, including two of the actors, are new to the theater. He doesn't mention that all three are disabled.

When he is finished, Sveta shuts the laptop and starts running through the house rules. Marina interrupts: "Give him here! He was planning to watch." She means Kolya, in the laptop. Sveta hands over the green computer, and Marina reanimates the Skype connection.

The play strings together scenes of well-meaning and not-so-well-meaning able-bodied people interacting with people with disabilities. These are puzzling, exceptional scenes, and they contrast with enactments of medical neglect, which is instantly recognizable to the audience: a woman dies because no one can be bothered to check ››

on her; a woman gives birth while getting yelled at. Everyone is disabled at some point, and everyone has been treated callously. Especially everyone who is here—here in Belarus and here at the Belarus Free Theatre. The after-show discussion, however, quickly makes clear that this simple message has not been made obvious enough.

The panel is assembled on what was a few minutes ago and perhaps still is the stage. It includes Marina, the director; Kolya, who is in the green laptop and whose voice comes through a speaker Marina is holding in her lap; two of the actors—Sasha, a striking blond long-haired college student who was paralyzed from the waist down in an accident about five years ago, and Vadim, an activist in his late twenties who has cerebral palsy and uses a wheelchair much of the time; and Mais, a journalism student who also has cerebral palsy. To begin the discussion, Kolya announces that all three have been accepted to the theater's school—Vadim and Sasha as actors and Mais as a student of playwriting.

One after another, audience members say that they never saw a disabled person growing up. "I didn't even understand what you were trying to tell us," a woman says testily. "Because *those people* have isolated themselves from us." Sveta hums the most famous bars from Beethoven's Ninth Symphony, miming hands on keyboard. "Those people" on stage look impassive. Natasha is lurking in the corner of the screen of the green laptop.

"I think I'll live to see a time when disabled people are seen the way gays are now," says Vadim. "It will be fashionable to have a gay friend." One gets the impression that Vadim believes that he has never met a gay person, certainly that there is none present: to him, queers are "those people." He continues, "But disabled people are like gays—whether you like it or not, they live among us."

Sveta and Nadya are both flushed. Nadya, who is sitting on the floor, puts her head in Sveta's lap and closes her eyes. Sveta places her hand on Nadya's shoulder, as though shielding her, and looks forward, at the stage. They stay like this.

Kolya, in the green laptop, tries to push the discussion forward. He talks about the time the theater organized a performance at the Minsk Conservatory. That is, they brought a piano and planted it in front of the conservatory, and they brought a blind girl, who played the piano. The conservatory does not accept applications from blind people. The girl who played that time later sang on Belarusian television, in a celebrity-judged talent show, and the celebrities cried.

"We are provocateurs from the arts," explains Natasha. She asks the audience to share their own ideas about what can be done.

The discussion feels endless, in part because no one, including the disabled actors, has the tools for thinking and talking about disability. There is no language in which to conduct this conversation, and no set of concepts to underpin it. It may be literally true that no one in the audience has ever talked or thought about disability. The burden of thinking about disability has fallen entirely to people with disabilities, and now three of these people, trapped in a panel discussion in which they can no longer pretend to be playing other people, reveal more about themselves than they'd like to.

"People keep saying that they can't get work because of their disabilities," Vadim suddenly blurts out. "But if you look at it closely, you'll see that they don't have a decent education or any motivation." They aren't being robbed of opportunities now, that is—they were robbed a long time ago. Mais, who has been silent, says that he was not allowed to apply to the journalism department of the university, despite being a published journalist. Belarus is a Soviet-style tyranny of bureaucracy, where for any activity there is a document that restricts it. There is, for example, a list of occupations disabled people are allowed to pursue: if an occupation is not on the list, it is forbidden. Journalism is not on the list. Nor is speech therapy, which was what Sasha wanted to study. She was, however, allowed to study psychology.

Sveta eventually loses patience with the rambling, hopeless tone of the conversation. She stands up and says, "We have to act!" Before that, and before Kolya and Natasha sign off with apologies—they have an important meeting to attend, to discuss the continued existence of the theater—Natasha says that she can't believe she is hearing what she has heard in the course of this discussion: "the poor gays" was a phrase someone used; "a typical cerebral-palsy gait" was another. Sveta and Nadya give barely perceptible shrugs. Unlike Natasha, they can believe it. But then, unlike Natasha, they don't live in London.

As people smoke outside and mingle inside, Sveta puts up a table in the middle of the room and puts on jazz. Dasha and the others start setting the table. This is the end-of-season party. Tomorrow some of the troupe goes on vacation while others go on tour. Marina is not helping set the table. She is dancing alone next to the table, her eyes half-closed.

• •

The sort of thing that happened during the discussion, that doesn't happen often. Sveta and Nadya rarely have to hear anything about "the gays." It's not that they live in an atmosphere of acceptance outside the tiny Belarus Free Theatre community—it's that they live in a cloak of invisibility.

People do stare at Sveta: she has a grown-out mohawk, a pierced lip, a swagger that is likely to make people wonder what gender she is. Some of her look dates back ››

to her days as a punk musician: for several years she toured with a hardcore group that broke up on the eve of one of the so-called elections in Belarus, when some of the group's members suggested it was time to tone down the politics in their music. Sveta walked away. It was then, or maybe a bit earlier, that she was showing her mother pictures from a tour. Here was the guitar player with his girlfriend, here was the accordion player, here was Olya, whose picture Sveta would set aside.

"Is Olya your girlfriend?" Sveta's mother asked.

"Yes," Sveta said, in part because she was taken by surprise. Also, it was true.

Sveta's mother didn't speak to her for two days after that. And then she started crying. She said that the news meant that Sveta had no future. She said that it was all her fault: she hadn't spent enough time with Sveta when she was a child, she had sent her to a boarding school for sickly children. Then they both cried. Sveta's mother said that she'd never have children. Sveta told her that there were ways. Sveta's mother asked her to reconsider. Sveta wouldn't. Then her mother cried. Then Sveta broke up with Olya.

Olya asked why. Sveta said, "I don't love you anymore." Olya said she didn't believe her. Sveta disappeared for a month.

A month turned out to be a long time. Or a month after you tell someone you love that you don't love them is a long time. When Sveta and Olya met up again, they both realized things were really over. After a while, Sveta met Yana and then decided to move in with her. "We are not your parents anymore," said her mother.

Sveta would go by her dad's garage to visit with him once a week. Her mother stayed silent for two years—until one day her father called to say, "Mom's made borscht. Come on over and bring Yana." Sveta went alone and got a hug and an apology from her mom.

It was Yana who introduced Sveta to the Belarus Free Theatre. Then there was the camping weekend with Nadya and Yana's announcement that she wasn't coming back, and three years when both Sveta and Nadya kept hedging their bets—when there wasn't a moment when at least one of them wasn't seeing someone else. Then Sveta suggested they move in together. Nadya resisted: she'd never lived with anyone, aside from her mother and grandmother. Then they spent months annoying each other: it turned out they did everything differently, from folding underwear to cooking. And then they settled into a routine of doing things that they felt like doing, when they seemed to need to be done. Nadya is more likely to tidy up. Sveta makes coffee in the morning.

They lived in a rented apartment in a large apartment bloc of the sort one can find on the outskirts of every post-Soviet city. Their neighbors were regular people who

regularly rejected Sveta and Nadya's attempts to create a sense of community or, say, get a recycling project started. Sveta had dreams of having a house—the kind where you wouldn't hear anyone's footsteps on the floor above you and no one would hear yours. She'd turn ideas and designs of the house over in her mind—it was a fantasy. Then one day there was an American journalist in town, doing a story on the theater, and Sveta was casting about for a way to entertain him after he'd seen what little there is to see in Minsk. She remembered that some Facebook friends lived on an old-fashioned farm about an hour outside the city. They went to visit, and the next thing Sveta and Nadya knew, they were buying a farm in the area, for the laughable sum of three thousand dollars. It took them a year and a half to get the house to look and function the way they wanted it to—with running water and an attic floor. It would have been cheaper to raze the old house and build anew, but it was all worth it for the sense of freedom, the fresh air, the quiet nights, and apples from your own orchard.

It's quite a thing in Belarus, building a house. If Sveta were a man, Nadya's mother would be bragging about the house. She would say, "My daughter has a man and they built a house." It would be an accomplishment like having a baby or having a great job. As it is, she doesn't mention it. Sveta's dad loves to come to the house to tend to the orchard. He takes care of it when the girls are away but also when they are there. He brags about the vegetables—the giant zucchinis, the delicious tomatoes—but not about his daughter so much. He is proud of Sveta and Nadya's accomplishment where nobody is looking, at the house itself. That's how the house functions for them: as a place where they don't see anyone they don't want to see, but also a place where they are never seen.

All of this—the pride of the house, the silence of the people in it—comes out suddenly, after a meeting with a prominent Belarusian cultural figure who Sveta and Nadya didn't know was gay. When they found out, the discovery, oddly, filled them with shame more than pride. What if their parents knew this person was queer? Would they reassess their view of the person, or of gay people? What does it mean, to know this about someone? What does it mean when other people know this about you? Where is your closet when you think you have left it? It suddenly seems like it's right here, just larger: it's the house, the car, and the theater.

But then, on public transport people stare. Sveta tries to explain this to herself: she wears ripped jeans, she has three earrings and a pierced lip, a mohawk, and the square shoulders and posture of someone who reads as male. She makes excuses for her fellow residents of Minsk. But she also gets tired of being stared at. Most of the time, she'd rather no one were looking. >> *Continued on p. 54*

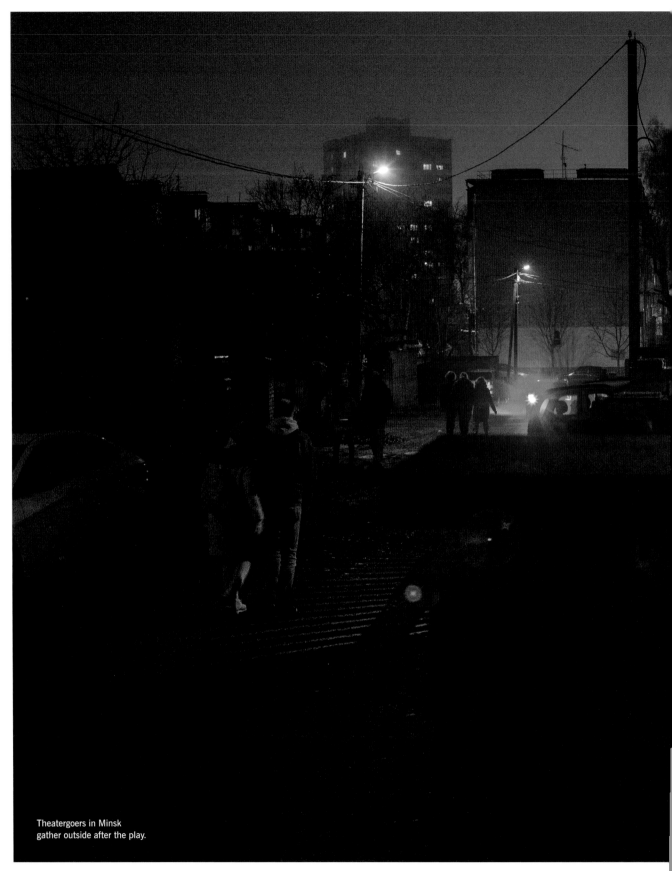

Theatergoers in Minsk
gather outside after the play.

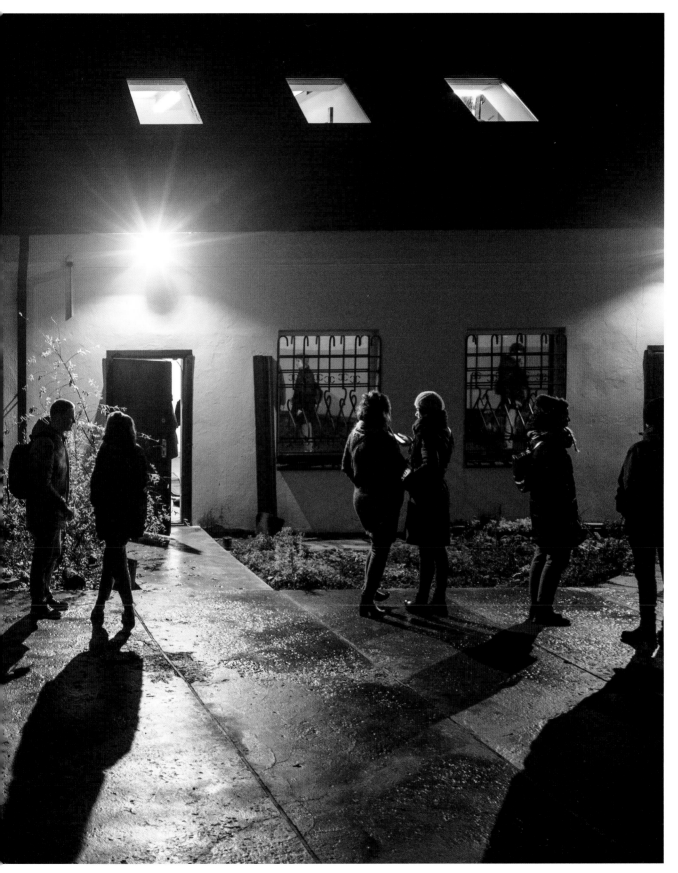

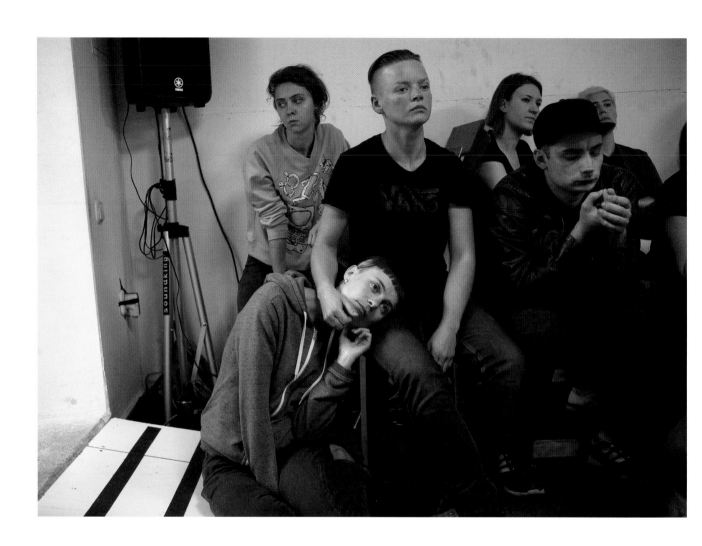

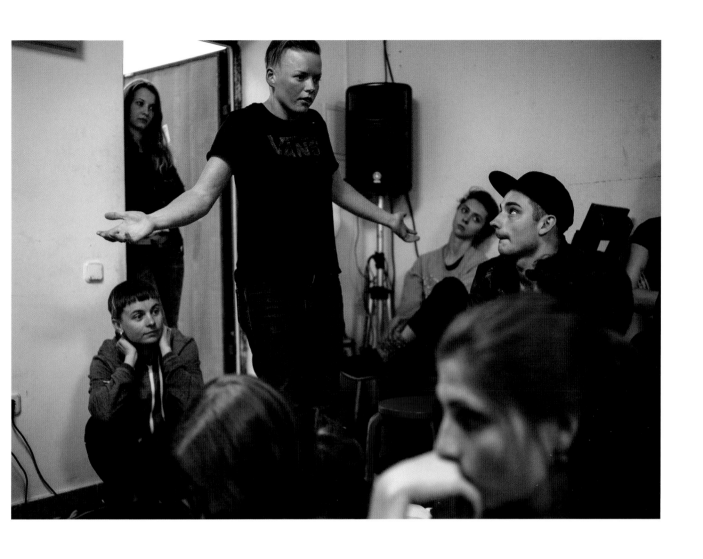

Sveta and Nadya attend a
post-performance discussion
with audience members.

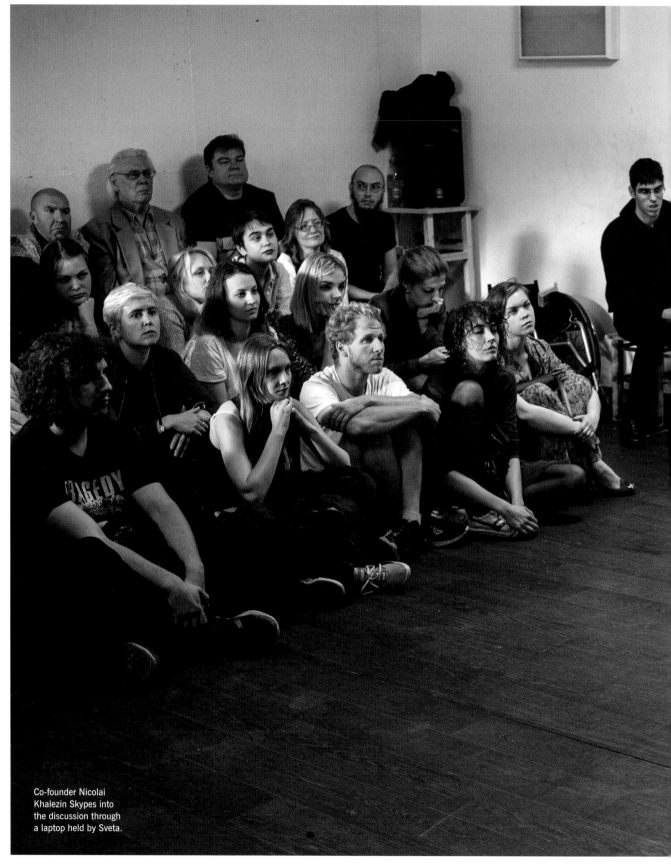

Co-founder Nicolai
Khalezin Skypes into
the discussion through
a laptop held by Sveta.

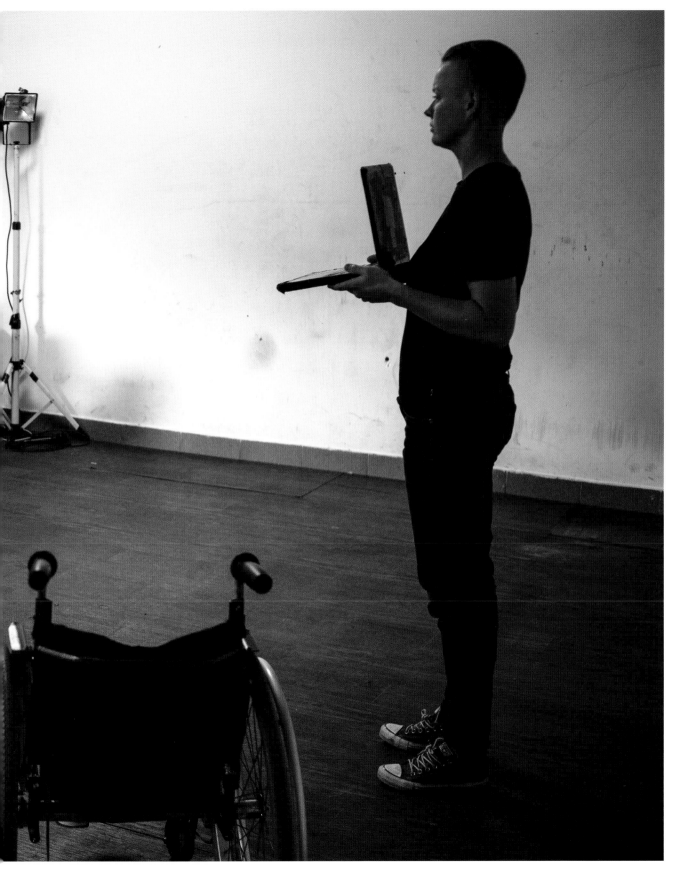

Nadya in central Minsk.

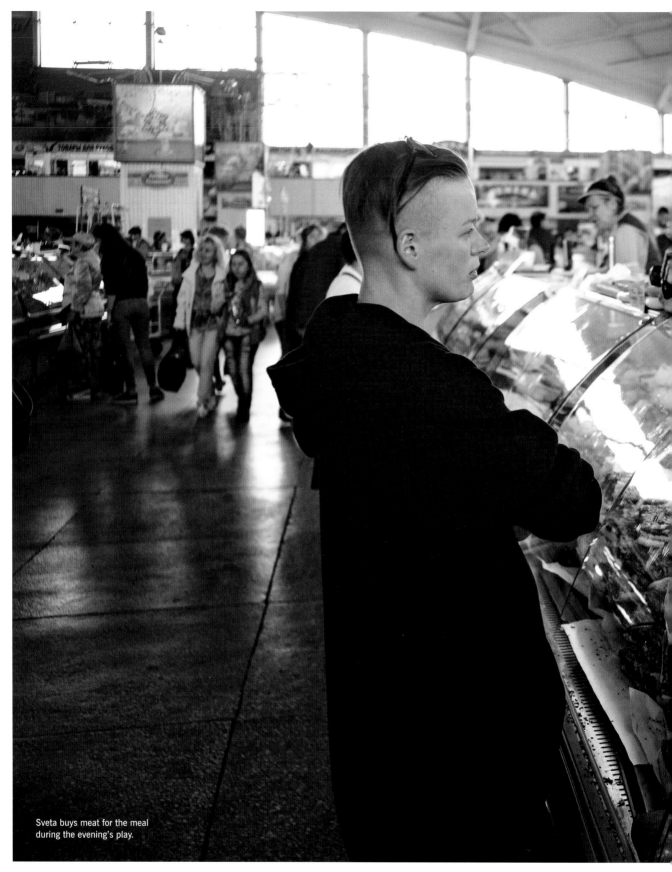

Sveta buys meat for the meal during the evening's play.

Sveta visits her
mother in Minsk.

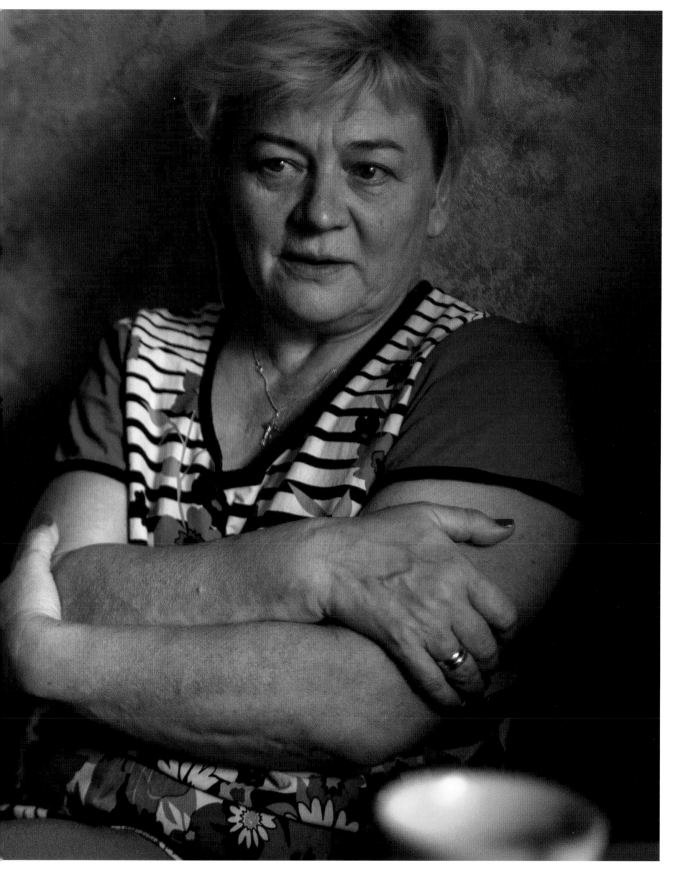

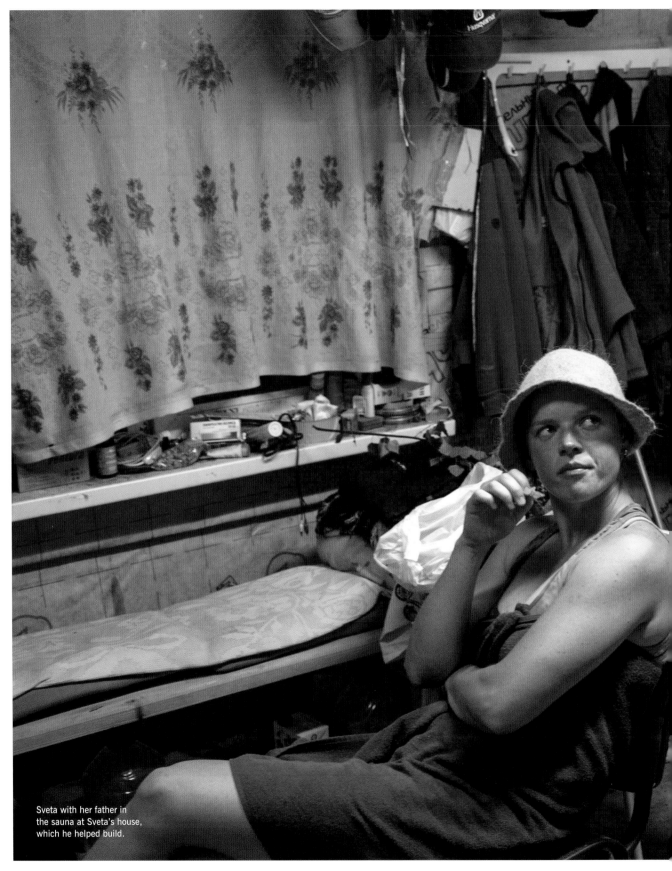

Sveta with her father in
the sauna at Sveta's house,
which he helped build.

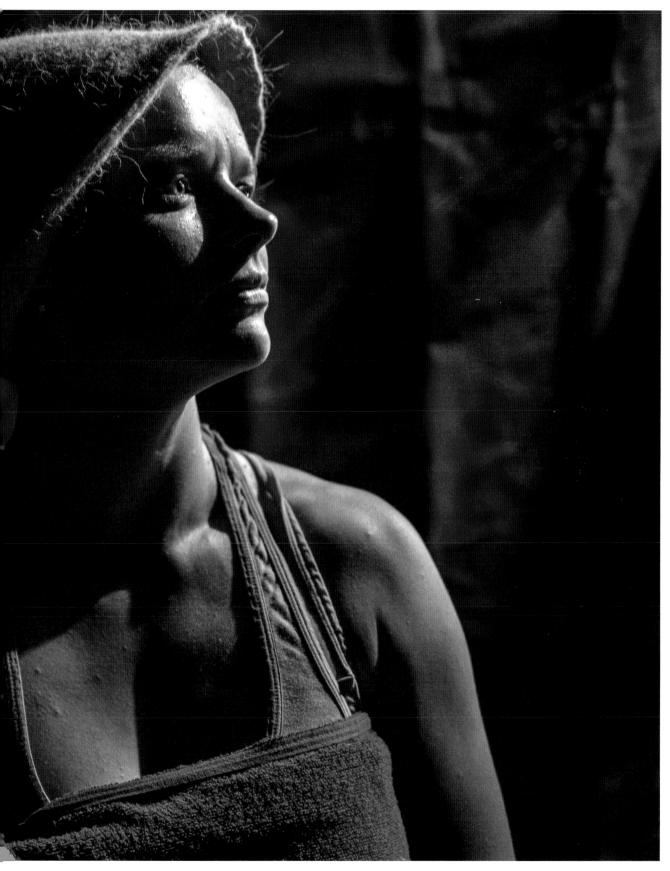

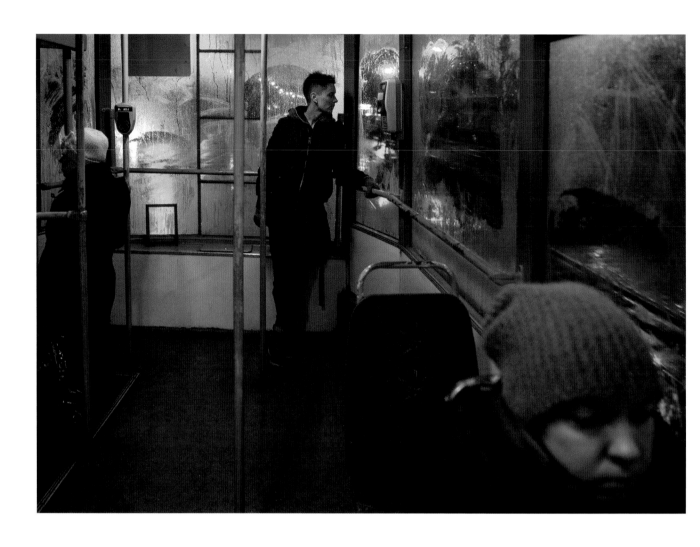

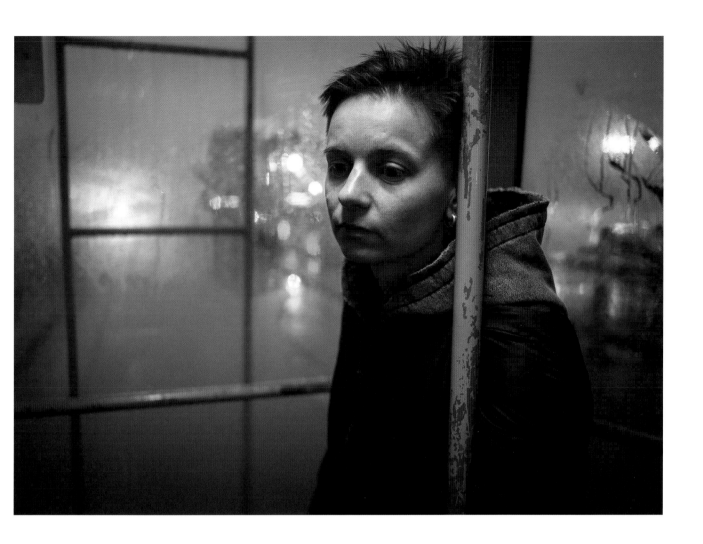

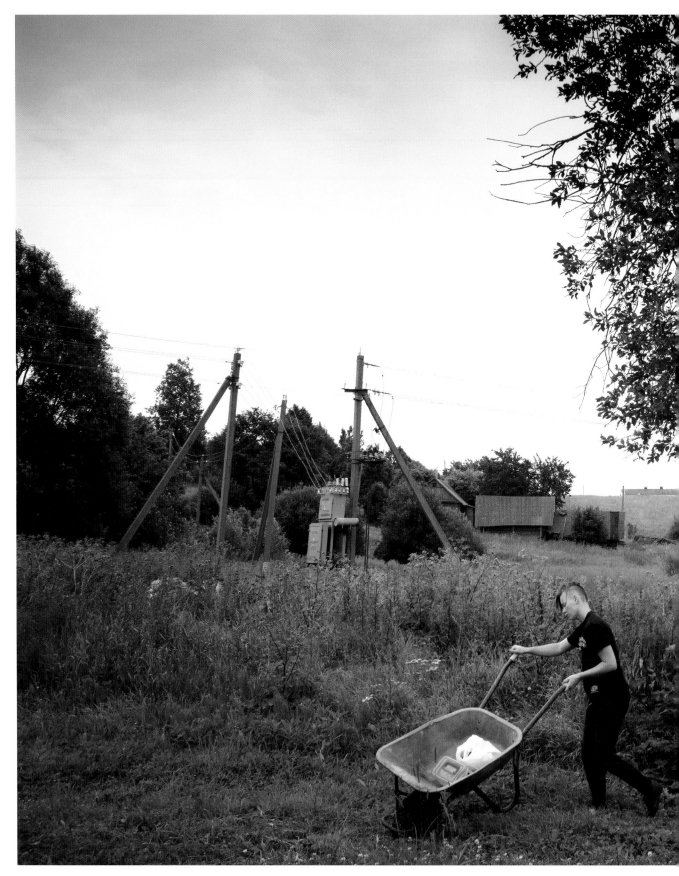

Sveta and Nadya live in a small village about an hour from Minsk, where they pride themselves on their self-sufficiency.

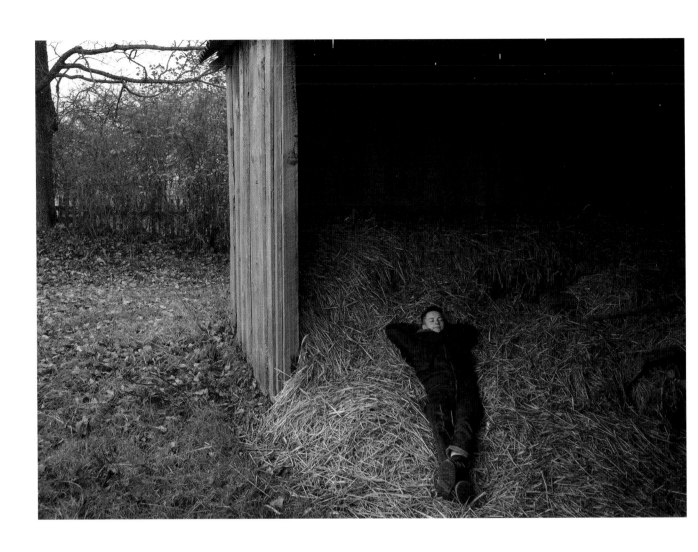

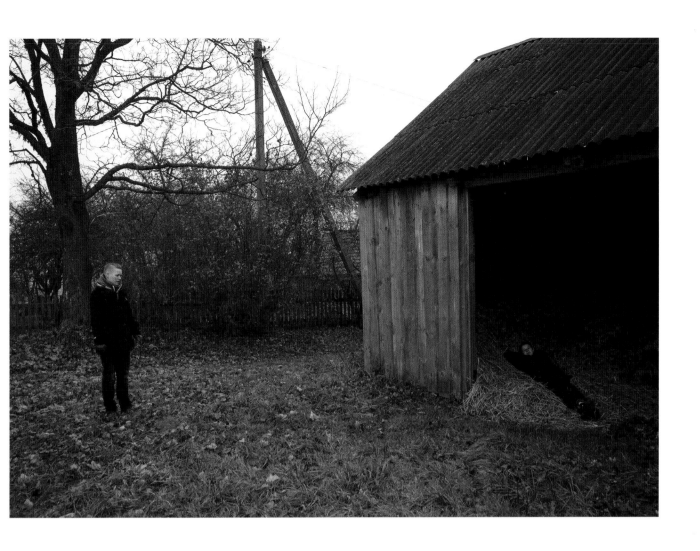

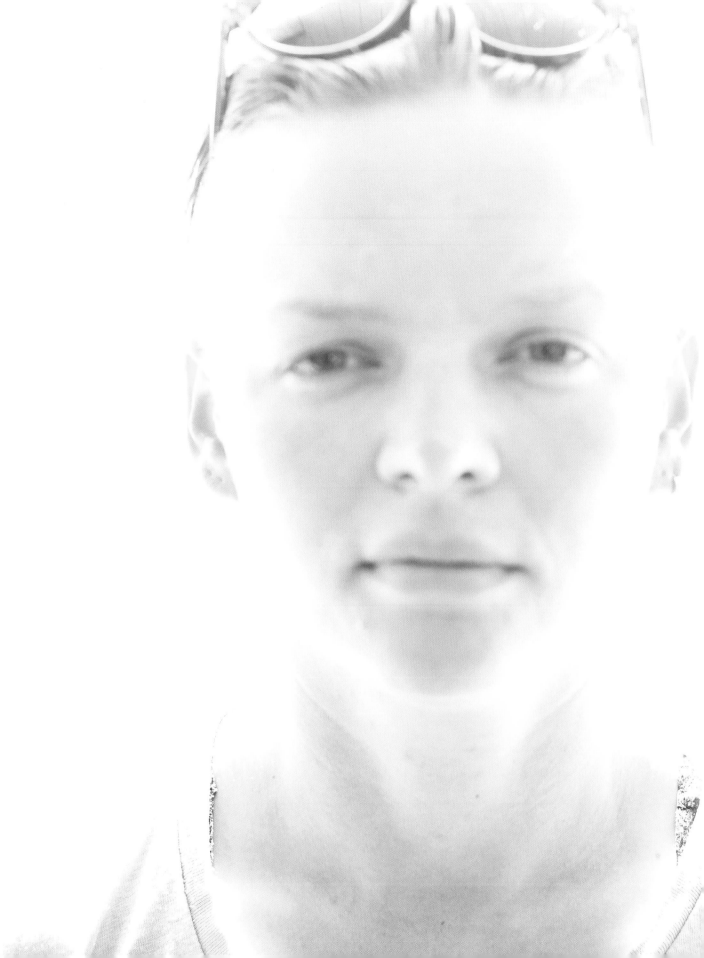

You see everything.

Early in *Burning Doors*, the production Belarus Free Theatre began touring in 2017, there is a scene in which actors repeatedly run at the audience, held back only by industrial-strength rubber bands that do double duty as visual allegories of being drawn and quartered. The play is based on the writing of three Russian political prisoners. One of them, Masha Alekhina of the protest art group Pussy Riot, acts in the production. A second, the artist Petr Pavlensky, was in and out of jail while the troupe was rehearsing and fled Russia for France around the time the play premiered. The third, the Ukrainian film director Oleg Sentsov, was serving a twenty-year sentence on charges of terrorism: he ostensibly planned to blow up a Lenin monument in Crimea (Sentsov was finally released in 2019, in a prisoner exchange, after serving five years).

The show uses writing by all three prisoner artists as well as Fyodor Dostoevsky and Michel Foucault. The connections among the texts are harsh and unsubtle, as is the production itself. There is screaming. There are several scenes that push the actors, the text, and the audience past the point of comfort and past the point where everything is clear: it becomes a matter of endurance. There is a scene in which a man is attacked repeatedly by bodies that throw themselves at him—for long minutes, until no one on stage is physically capable of continuing. Then there is a scene in which men stand with the arms extended and dinner plates are piled onto those outstretched arms, stacking up until the men can no longer hold them up—and then, one by one, they give in and give up one of their own. This is a torture scene (there are many). Then there is more screaming, and singing at the top of the cast's lungs. This production denounces an economy of movement or device: it does everything, and it says everything, repeatedly. Perhaps this is what happens when you are always a foreigner to your audience and they are always foreigners to you: you give up on shades of gray, and you make double and triple sure that your message is seen and heard. Since the message is political, in some cities there is even a banner at the end. It says "Free Sentsov."

About a year into the *Burning Doors* run, Sentsov goes on a hunger strike. He is demanding the release of all Ukrainian political prisoners in Russia—this is how the world learns, or is given the opportunity to learn, that the number is more than sixty. The Kremlin responds by portraying Sentsov as a terrorist who is trying to blackmail the Russian government. For a while, it looks like Sentsov is going to die. During the theater's Canadian tour in the summer of 2018, every show ends with the unfurling of a banner . Before Canada, there was Australia, the United States, Germany, and Finland. In Finland, there was a problem with the video projector. They spent hours trying to fix it and finally had to give up. The show went on without the projection, and the audience didn't miss a thing: that must be what happens when a show runs a surplus of visuals, words, and gestures.

Sveta's and Nadya's jobs change when they are abroad. There are bigger tasks: the video projectors in Tampere, Finland, are numerous and complicated—this is not the pull-down screen and MacBook that they use in Minsk. The cast is bigger than in any one production back home, and though everyone is still nominally responsible for their own costumes, somehow there is the business of ironing and washing and just managing all those dressing rooms. In Finland, Sveta spent an exasperated hour on the hunt for Alekhina's simple black dress, which seemed to vanish from her dressing room (Nadya had taken it for ironing). There is the challenge of fitting the stage set to an unfamliar stage: *Burning Doors* decorations include a bathtub full of water, two toilets, and rubber bands, a hoop, and a system for suspending actors during some of the torture scenes. Sveta wears all black, as stage hands do, but so do all the actors in this production, so it's not always clear whether Sveta means to be seen or not seen. As the gut-wrenching last scene draws to its close, with the lead male actor, suspended by his hands, urinating into the bucket from which he has been drinking, Sveta appears as a shadow, pouring flammable liquid into small vessels along the back of the stage. She then joins the cast on stage, singing. Then, as a shadow again, she sets the liquid on fire. Then there is a pause—a fraction of a second in New York, a full two minutes in Melbourne—before the audience realizes that this time the play is really over and begins to applaud. Then, as they are leaving, Sveta is invisible again, but on stage, cleaning up the urine.

The theater changes when it's abroad: the people are the same as in Minsk, with the slight difference that the touring troupe is made up of actors who have been with the theater longer while many of those who play the converted garage in Minsk are students. But the actors' bodies seem to get bigger abroad, in order to fill larger spaces, and their voices appear to get louder, perhaps to accommodate the growing number of words. Sveta and Nadya's jobs get bigger too: they get swipe cards or keys to some of the world's largest and most prominent theaters—the Melbourne Arts Center, LaMama in New York City—for the few days or couple of weeks that they run the backstage operation on tour.

• •

Sveta likes LaMama the best. Everyplace else feels like they are on tour, but LaMama feels like home. It looks, in fact, like it could be a scaled-up—vastly scaled-up—version of the Minsk garage. The audience sits on folding chairs, the walls are tiled and cracked, and Kolya is driven crazy by the theater's many organizational failures. The New York audience is earnest, the optimal audience for this production. During the fake press conference in the middle of the show, they ask Alekhina ››

questions like "What was it like to return to normal life?" ("What normal life?" is the answer) and, of course, "How are you able to do this without being persecuted?" The questioner has no information on whether the Belarus Free Theatre is persecuted, but they all seem so normal sitting there at a folding table on the stage, the thinking seems to go, that they *must not* be persecuted. If they were, what would that mean for all the normal, non-persecuted people in the audience?

A woman addresses Alekhina: "Could you explain the scene in the bathtub, the scene—where you are—where you are being—drowned?"

She is referring to a torture scene in which Alekhina, sitting in the bathtub, repeatedly recites a poem by Yan Satunovsky while a man, who is in the bathtub with her, keeps grabbing her by the hair and dunking her face in, again and again, holding her underwater longer each time—and when she emerges, every time, she resumes the recitation of the poem. But the claw-footed bathtub is so normal, beautiful even. And the poem, which the audience can read in English in the surtitles, is vaguely absurdist and sort of silly. Can something that looks both so ordinary and so beautiful be as frightening and important as it may seem? On stage, the Belarus Free Theatre goes to great lengths to explain that it can. Off stage, the Belarus Free Theatre people are only a bit less likely than others to mistake beauty and familiarity for freedom.

• •

Nadya thinks of herself and Sveta as Kolya and Natasha's successors. Kolya and Natasha are in charge of things in general, and Sveta and Nadya are in charge of things in Minsk. Kolya and Natasha are a couple too, like Sveta and Nadya. But the couples are not exactly each other's mirror image—more like a negative and a print. Since Kolya and Natasha went into exile, they have learned the hustle of keeping themselves ever relevant, ever in the headlines, and ever fundraising. They have excelled at this: festivals, prizes, glowing reviews, and spots on best-of lists have rained down on them. Sveta and Nadya's hustle is the opposite: if making noise is the secret of survival in the West, lying low is the trick to staying alive in Minsk.

It's like Sveta has been performing a disappearing act for years. Time was, she had her own punk rock band—part of what was, at the time, a thriving and politically charged punk rock scene in Belarus. They played large halls in Poland and, occasionally, in Belarus. Once Sveta became part of the Belarus Free Theatre community, the band toured with the theater, too. Then there was an election—it's hard, now, to remember which election it was, during what year, because the sole viable candidate is always the same person—and Sveta's bandmates suggested that maybe they should separate music from politics. She got so mad that she

disbanded the group. That meant, for the most part, getting off the stage.

Things in Belarus always have a way of getting tense around the elections. It's when the regime becomes scared that its weakness will show. The people of Belarus, who normally have no say in what happens in their country, their city, and, sometimes, their own lives, are suddenly given a chance to have their say in politics—at least nominally. The stakes are raised. This is when there are arrests—and the fear of arrests.

There was the 2006 election, for example. Back then there was sustained protest, with people camping out in central Minsk for several days. Sveta was sick with a bad cold and hating every minute that she had to be missing protests. On the third day, when her fever barely subsided, she decided that she could at least deliver some food and warmth to the protesters. She packed up her car with sandwiches and blankets. She was approaching the square when a police officer stopped her and searched the car. Then he made her follow him to a detention center, where she was promptly arrested. He filled out a protocol of arrest, putting down that Sveta had "stood in the square shouting anti-state slogans such as 'Long live Belarus.'" It is a measure of the absurdity of the Belarusian regime that the national-liberation slogan "Long live Belarus" is considered an affront to the state.

Sveta was sentenced to seven days' administrative arrest. She found herself crying at the unfairness of it—not the sentence itself, which was a risk she knew she was taking, but the lies and absurdity: she hadn't even gotten to the square. And to make things even more humiliating, she had driven herself to the detention center. The detention center had been freshly constructed—there was no heat yet (it was March in Minsk, with temperatures hovering around freezing) and no mattresses. Sveta, alone in a cell, heard that other people in the hallway were being fed but that first night, she wasn't—she had apparently arrived too late. Her period started. The misery seemed bottomless.

She wouldn't wish it on anyone, but the experience of seven days behind bars taught her something about appreciating the everyday. She often thinks about the bread in jail—a single slice that's handed out before the meal, and you eat it, all of it, and you make sure there is not a crumb left. As finite as that slice of bread is, that week in jail seemed infinite.

She has had many confrontations with the police since. For about five years the theater had a space they called the "Khatka"—a little home. When they first started, they played bars in town. The Khatka was their first permanent space, and they felt like they lived there, beyond rehearsals and shows, it was just theirs. There was a day—Kolya and Natasha et al. were already in exile—when they started a show as usual, by greeting the audience, and then a man in a black fur hat stepped onto the ››

stage. He looked striking, and everyone but the cast thought he was part of the show. "Why is the floor black?" he asked, like he was threatening someone. He was the head of the Minsk special forces. Then everyone who was at the Khatka was loaded onto buses and transported to a police station for processing. The cops told audience members that they'd lose their jobs or be expelled from their schools. They took down everyone's name.

This wasn't the first time the police came to the Khatka, but it was the worst. The landlord said, "You have to understand." They did, of course. The theater packed up and moved all their stage sets to a tiny garage they rented. They had themselves a group cry: they'd lost their home. For the next year and a half, Belarus Free Theatre played spaces it rented by the hour—and rented a truck to take sets to and from the garage every time. They still managed to maintain a three-shows-a-week schedule. Then they found the converted garage they use now. Nothing will ever feel as permanent as the Khatka, though.

In March 2017 there were protests again. Sveta went with three people from the theater. Nadya stayed behind to provide support from the rear, if needed. Soon enough Sveta and the three others were inside a prisoner transport—and there were dozens more of these vehicles, as far as the eye could see. They were taken to a police station and lined up against the wall in some hallway. Sveta was pretty experienced by now: she had brought a thermos full of tea and a bag of nuts, and she was the first to ask where the bathroom is. After a few hours, three of them were fingerprinted and released but one—Seryozha, the only man in that group of four—was told to stay behind.

Seryozha's hearing was the next day.

"Are you employed?" the judge asked.

"Not officially," he responded. "I work at the Free Theatre."

"Did you take part in the illegal protest?"

"No. I wanted to, but the police didn't let me."

"Why did you want to?"

"I disagree with the government."

It turned out Seryozha was a hero. Sveta knew he was a good guy and a great dancer, but she hadn't expected this. You'd think that this kind of political determination came with the territory at the Belarus Free Theatre, but it actually took her by surprise.

• •

Sveta felt it happen the first time she traveled abroad. As with any profound feeling, it may be best described with a cliché. "It's like a breath of fresh air" describes it. There is a Russian-language cliché, too: "spreading one's shoulders." Sveta has come to know

the feeling. The other thing that happens is that she finds herself smiling. It all has to do with not having to protect yourself and those for whom you are responsible from the outside world. It also has to do with being visible and intelligible to the world. Sveta's ripped jeans, pierced lip, shaved sides of the head read as nothing but otherness in Belarus. She is incomprehensible. She and Nadya together are incomprehensible too: a lanky young woman in jeans and another, sturdier and stranger and perhaps not even a woman, is what the Belarusians see, when they see the couple outside their car, their farmhouse, or their theater. In the West, people see them: they see young lesbians, a butch-butch couple, looking both timeless and a bit like throwbacks to the early 1990s.

With all the touring, and with the leadership of the theater living in exile, emigration is more than an option. It's a question that keeps asking itself. When? Where? Are you sure?

For a while Sveta thought that they, or at least she, would move to the United States. With the election of Donald Trump, Sveta has been thinking of America less. London is too loud. She'd rather live in nature. She does, in fact, live in nature—and continues to put down ever firmer roots there, with every zucchini planted.

Nadya says she doesn't think about it, ever. Not even when she is waiting for Sveta and the others to come back from a protest—or not. Not even when they asked her to stay in the theater when Seryozha was in jail and the troupe went there to sing a song about bringing down the walls of a jail. Loosely translated from Catalan poet Lluís Llachs' anti-Franco protest song, in Russian it said,

> Let's bring this jail down,
> These walls shouldn't be here.
> So let them fall, fall, fall,
> For they have long been frail.
>
> And if you put your shoulder to it,
> And if I push along with you,
> Then the walls will fall, fall, fall.
> And we will breathe freely.

She wasn't thinking about emigrating then either. But there is one nagging idea. Sveta wants to have a baby, and that, Nadya thinks, may change everything. Their bubble of internal immigration can't hold a baby. They may have to leave then.

But before that happens, Sveta thinks—and she is self-conscious about thinking this, because it sounds like another cliché—she'd like to do something important at home. She is already doing something important: the theater. She is not done.

>> *Continued on p. 116*

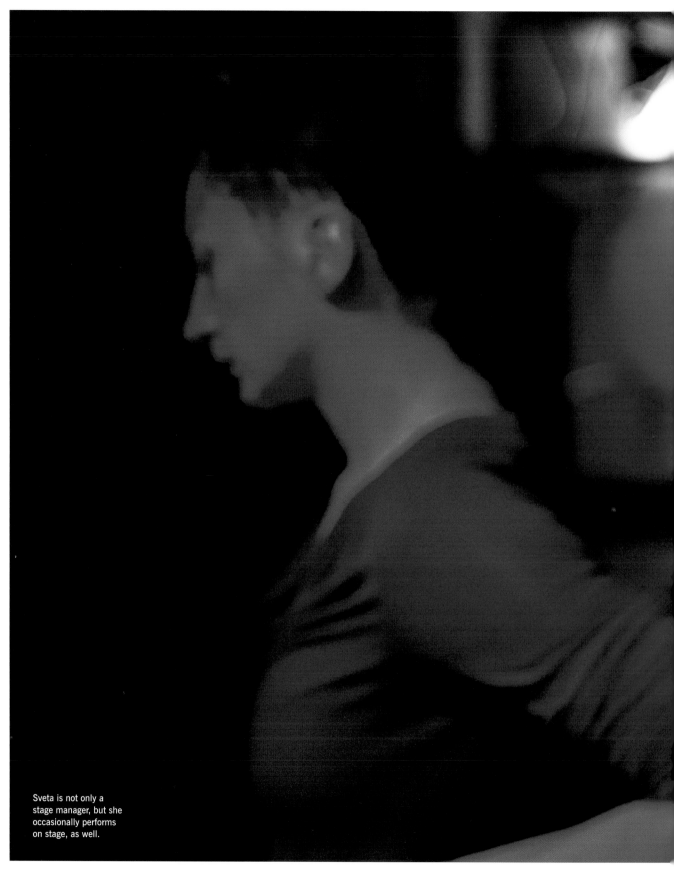

Sveta is not only a
stage manager, but she
occasionally performs
on stage, as well.

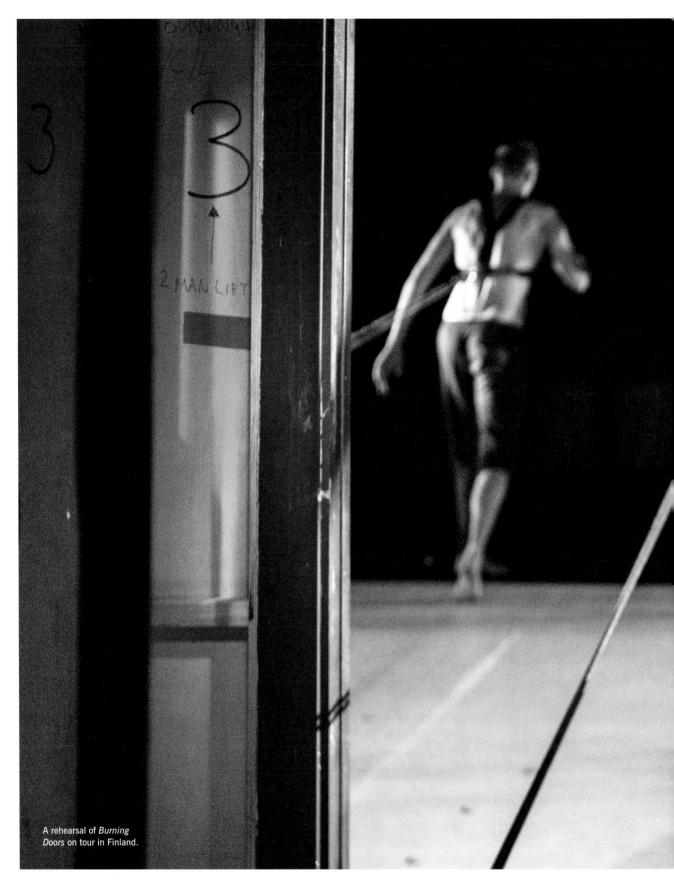

A rehearsal of *Burning Doors* on tour in Finland.

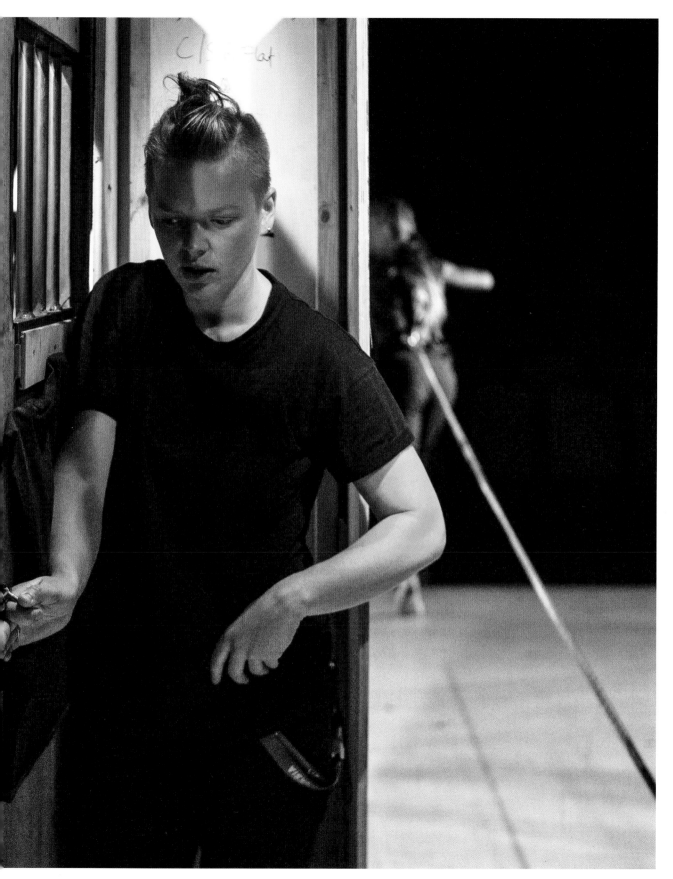

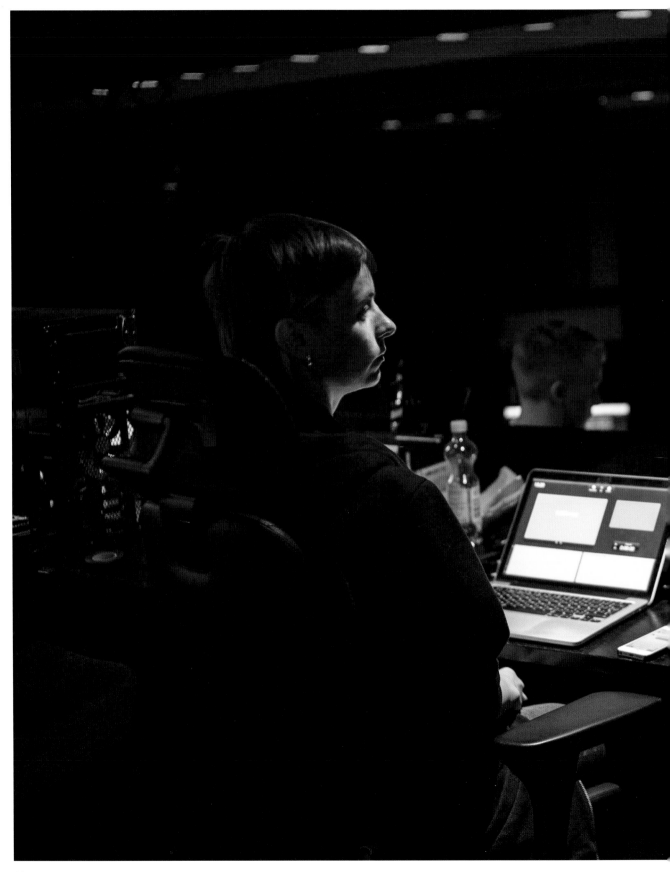

Nadya supervises the sound and lighting crew.

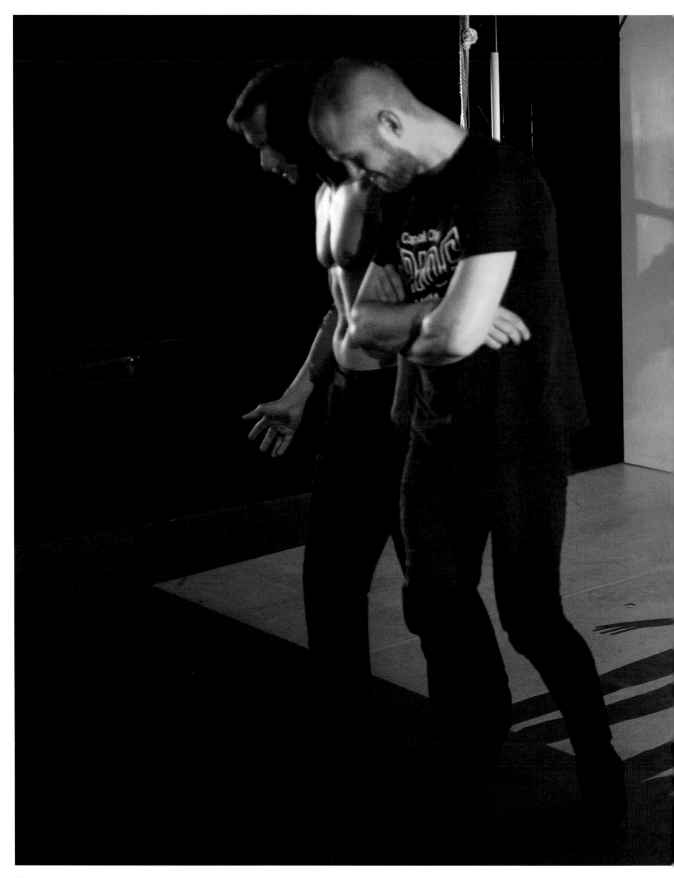

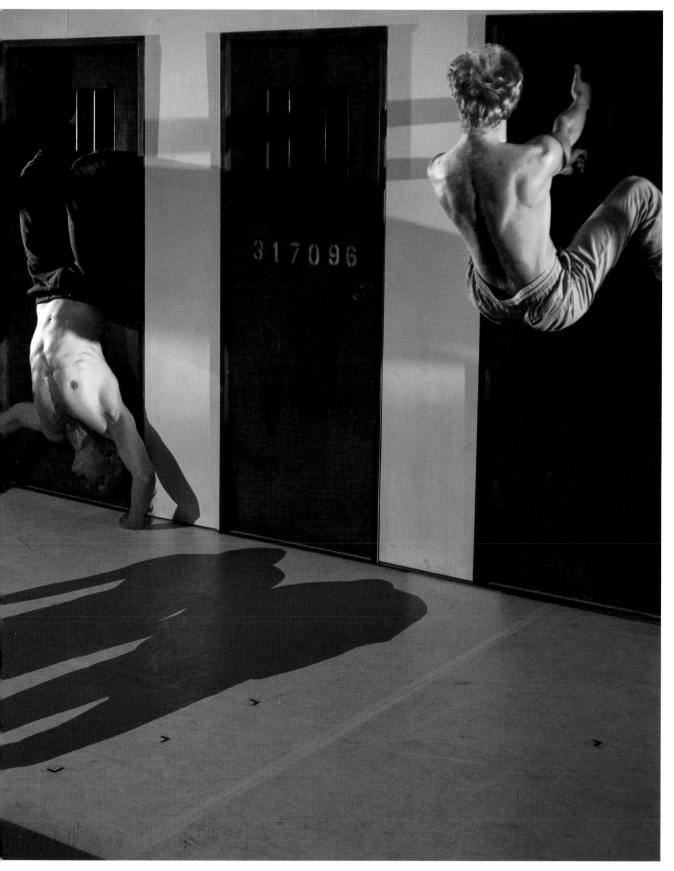

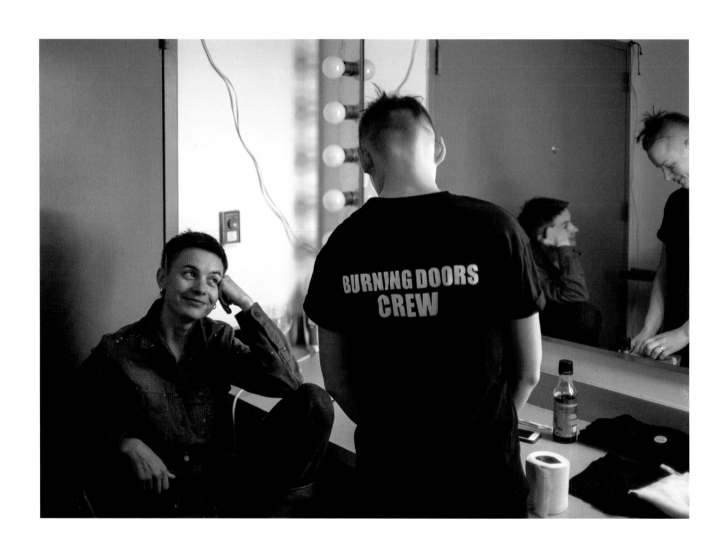

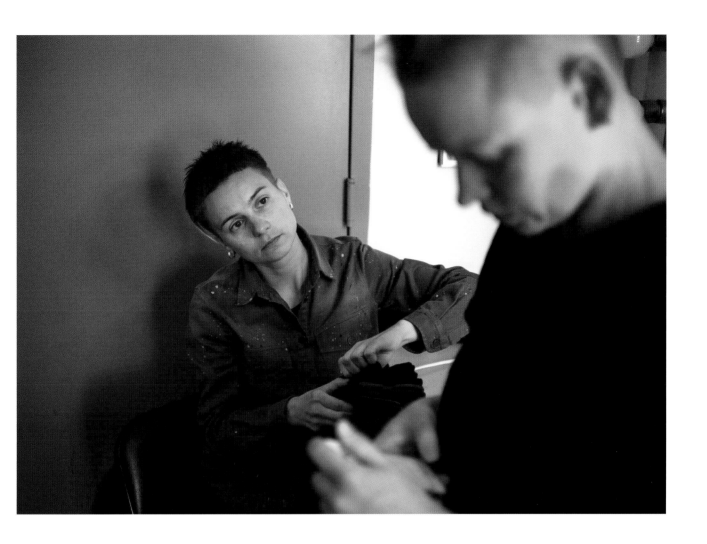

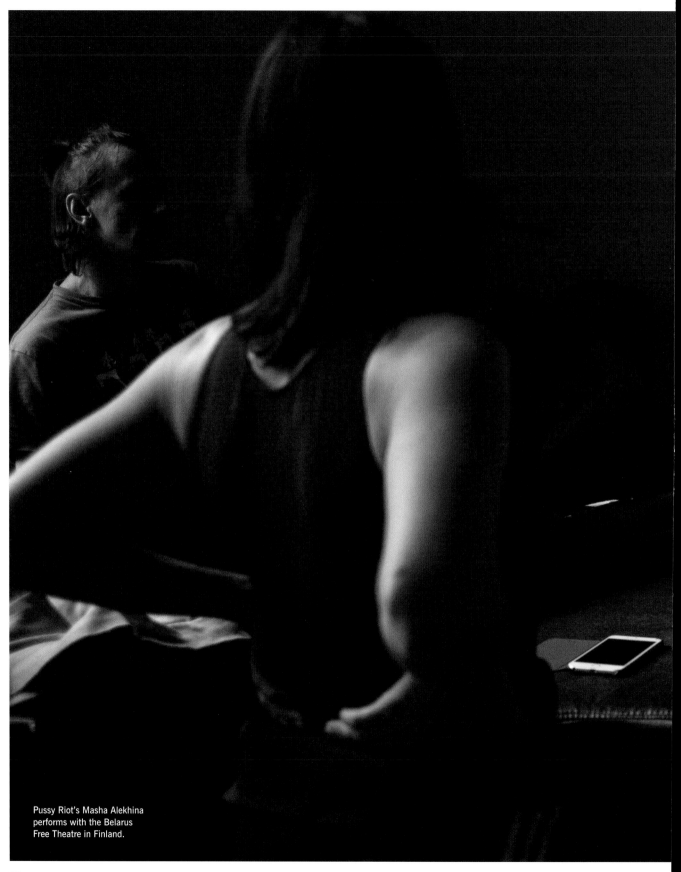

Pussy Riot's Masha Alekhina
performs with the Belarus
Free Theatre in Finland.

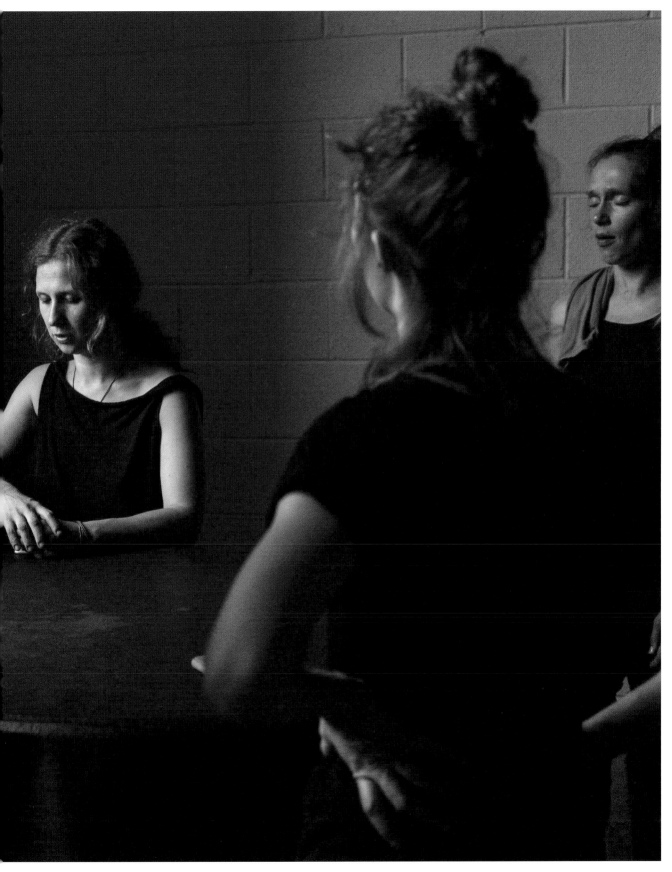

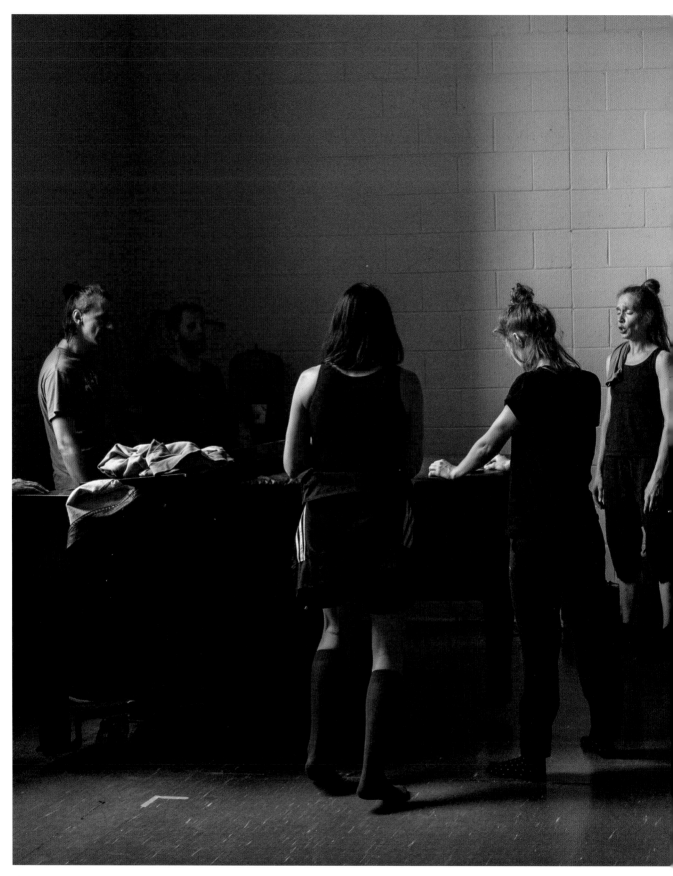

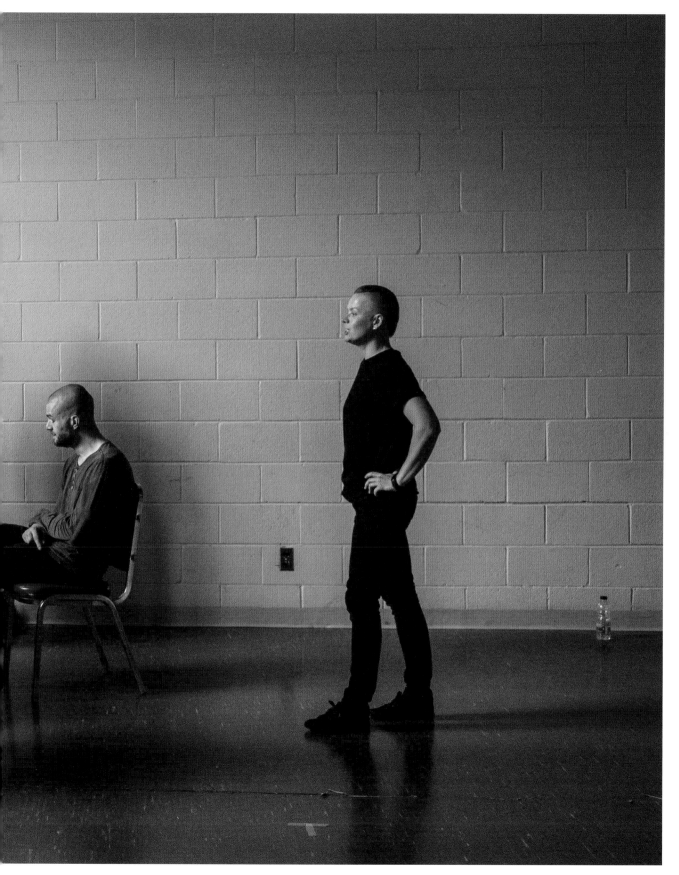

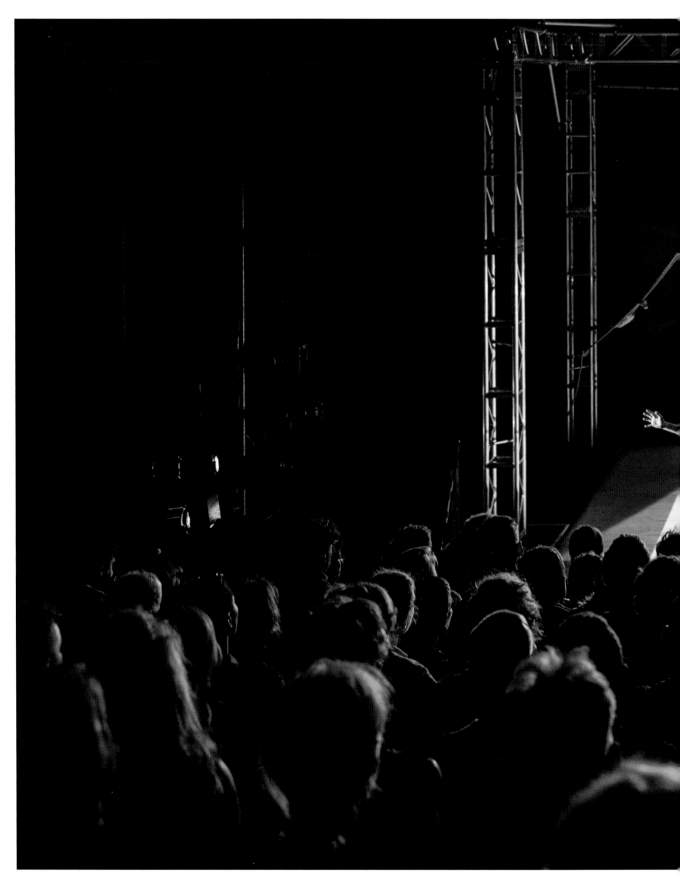

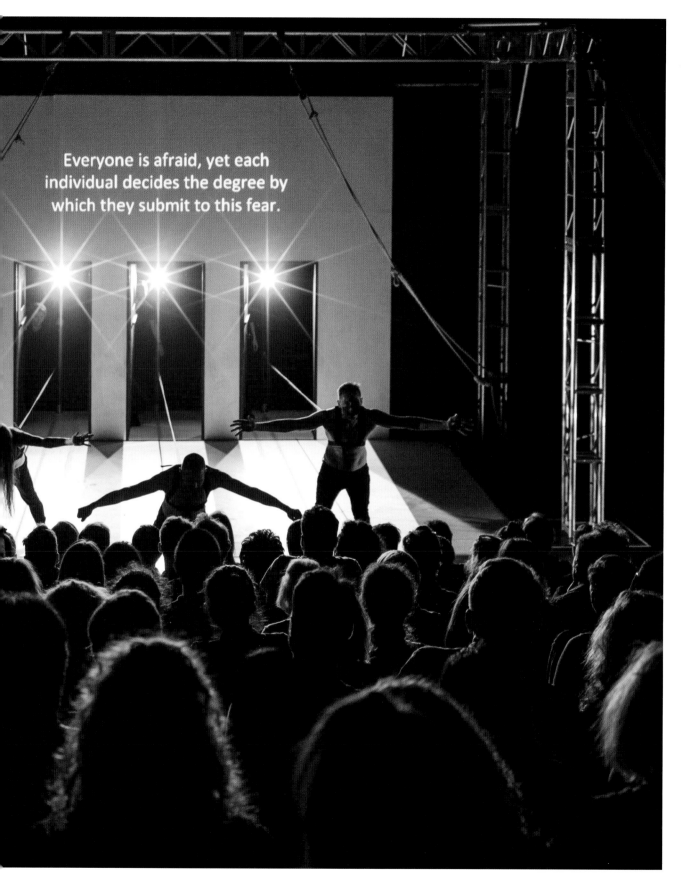

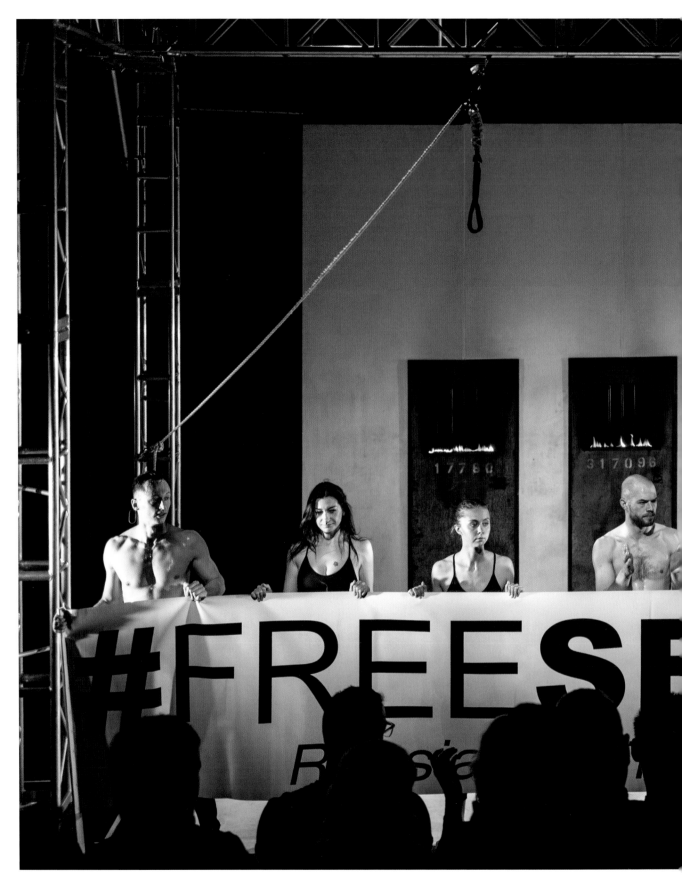

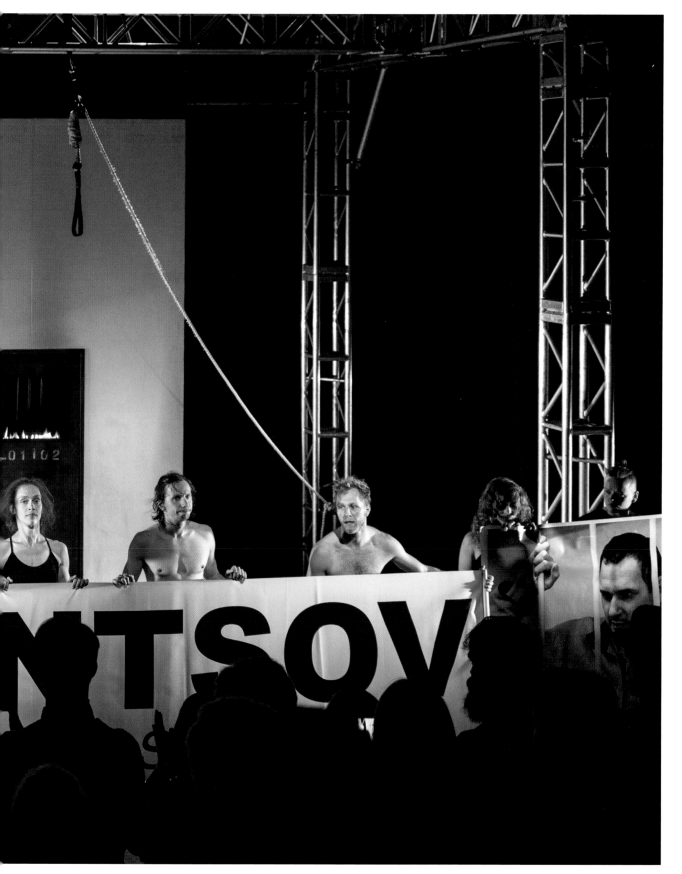

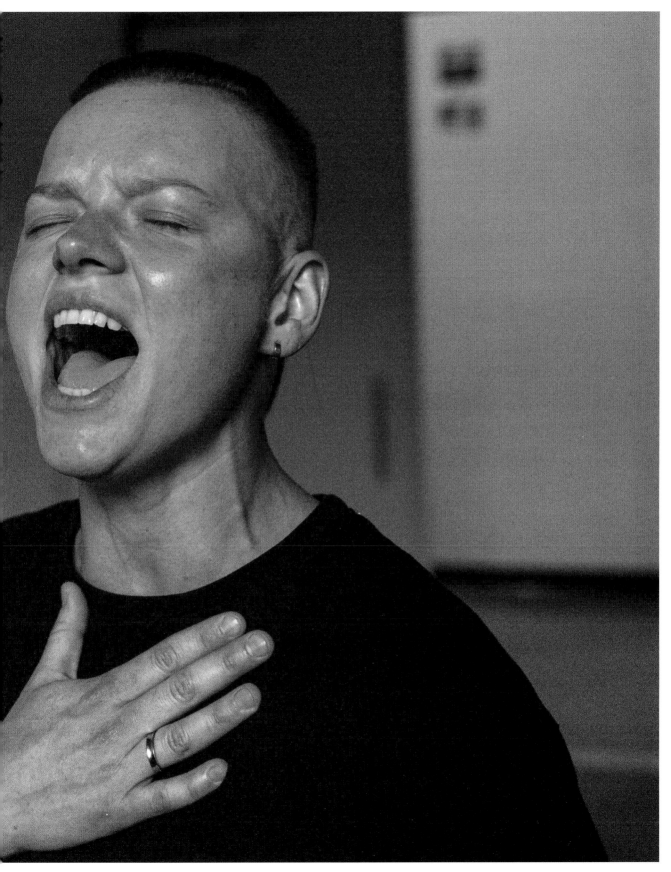

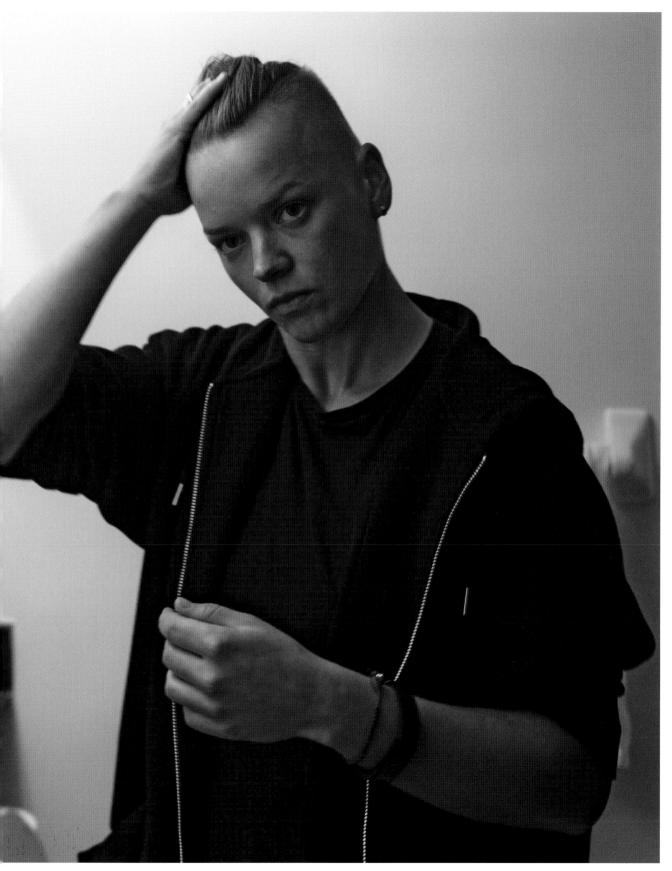

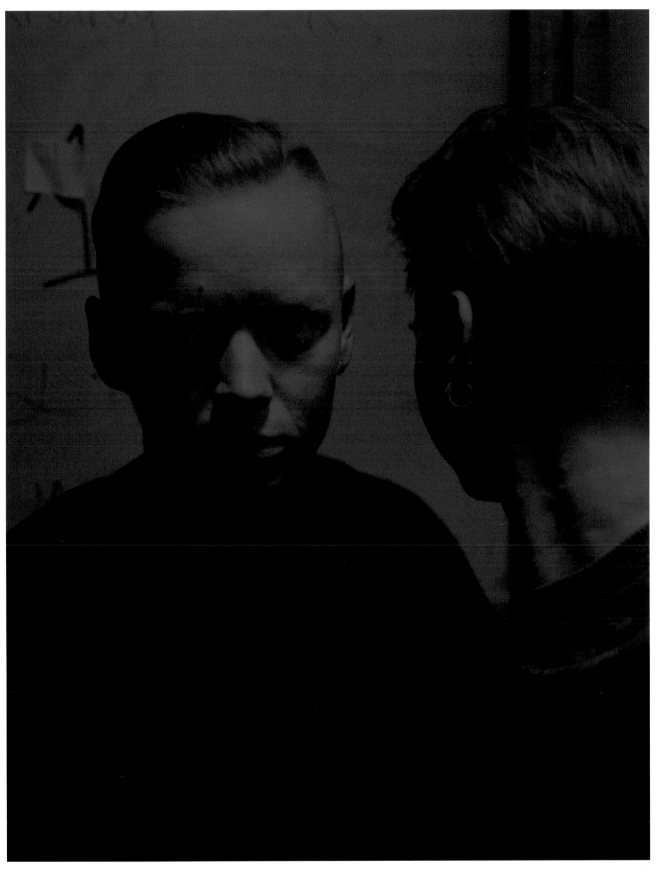

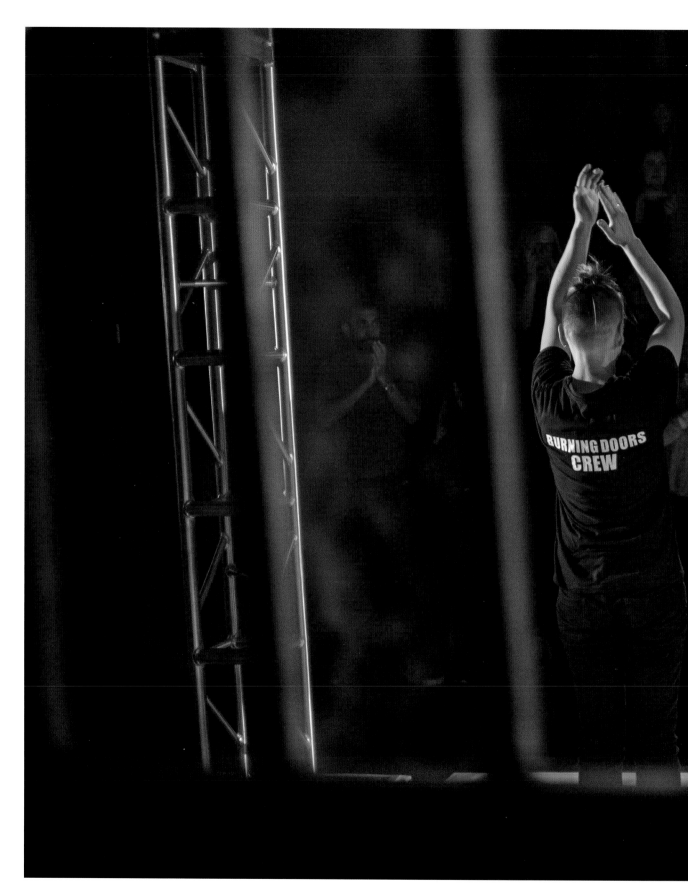

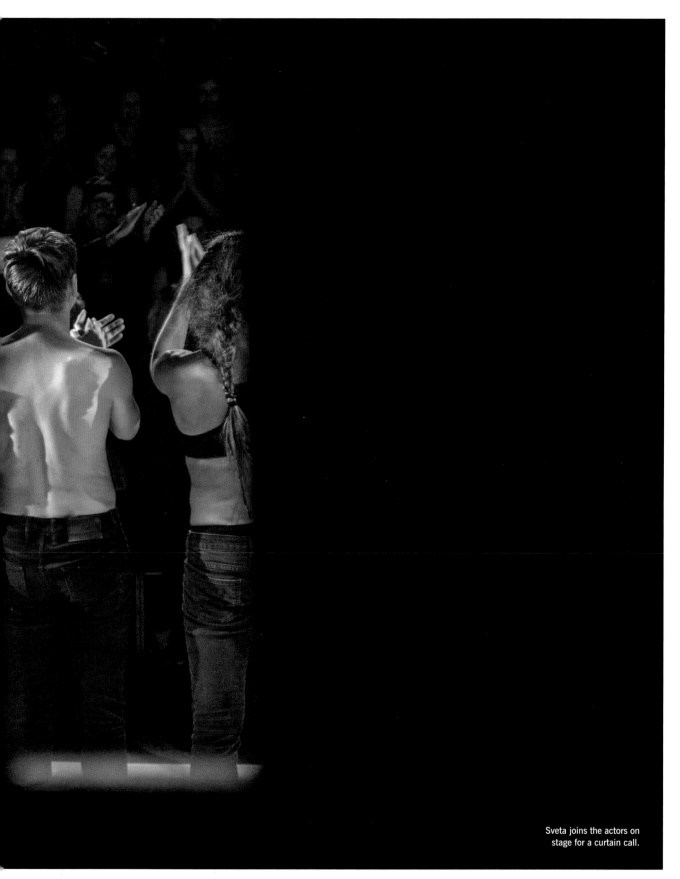

Sveta joins the actors on
stage for a curtain call.

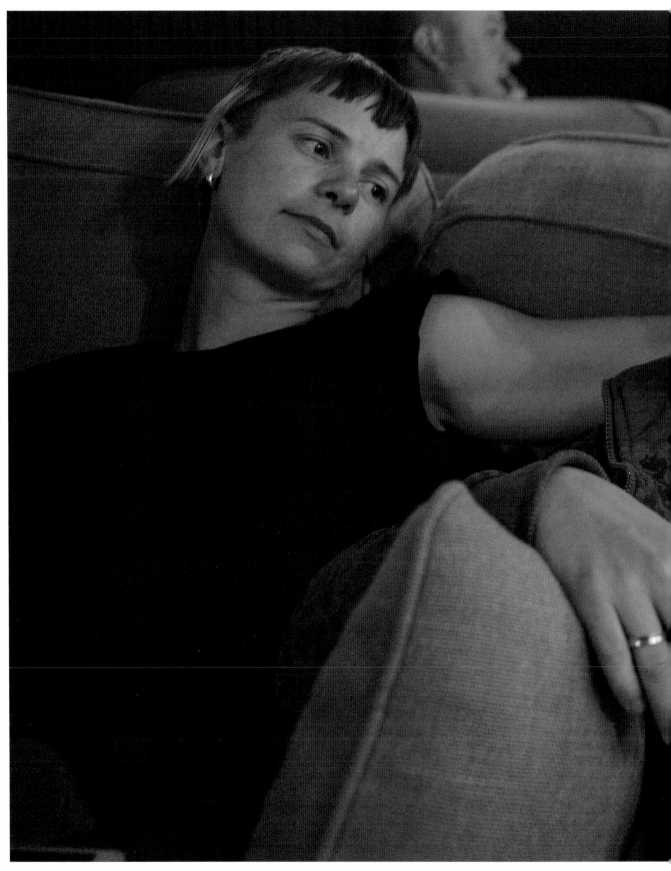

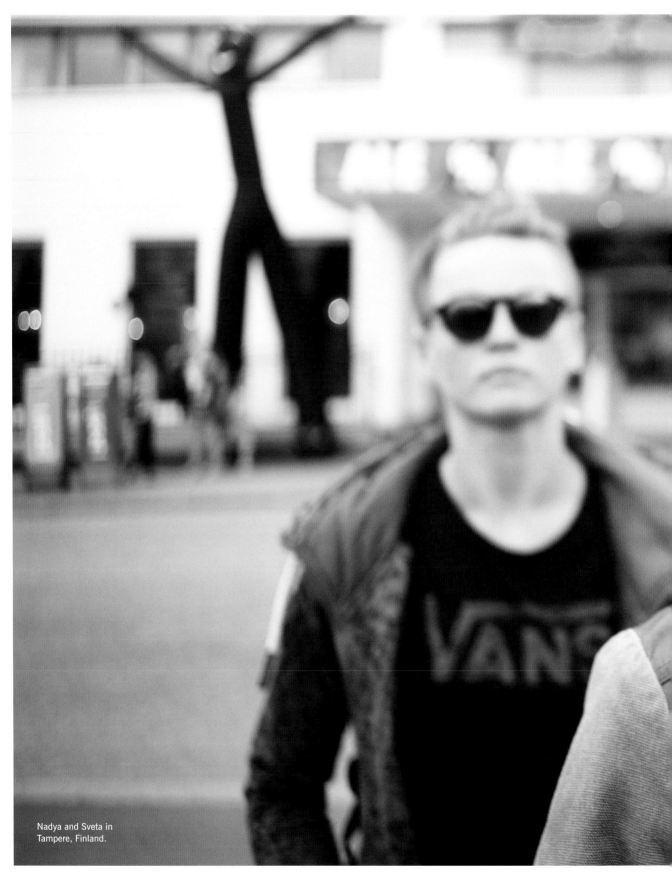

Nadya and Sveta in
Tampere, Finland.

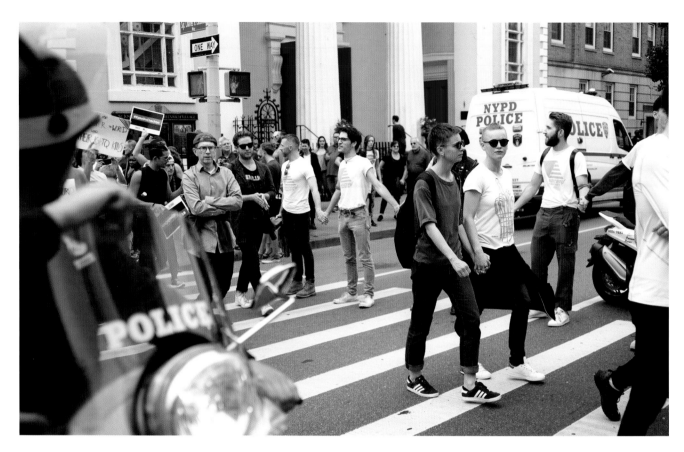

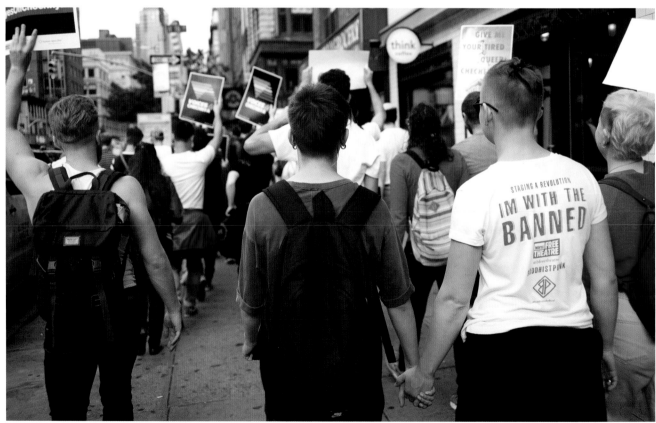

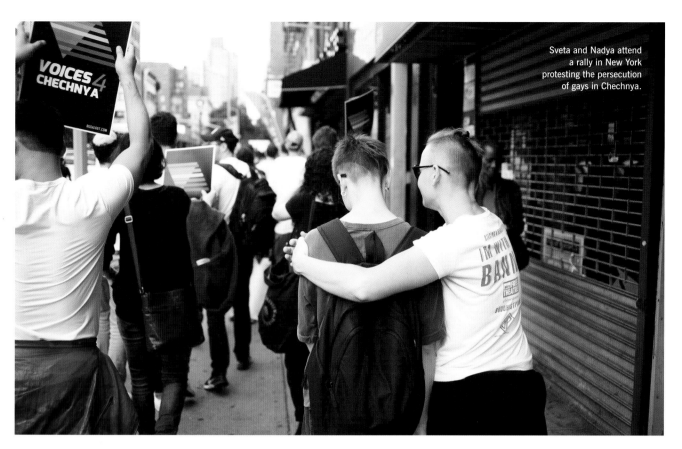

Sveta and Nadya attend a rally in New York protesting the persecution of gays in Chechnya.

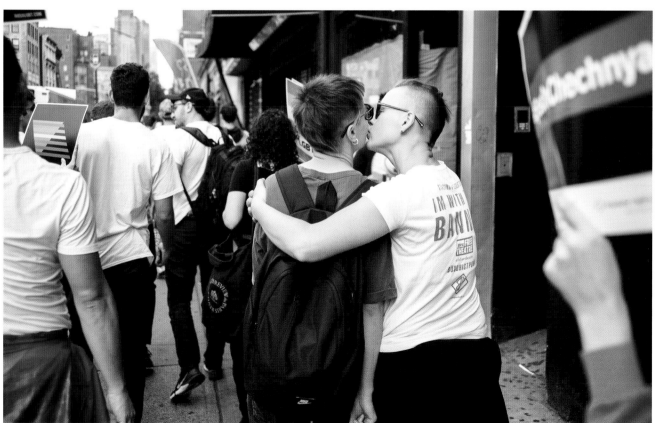

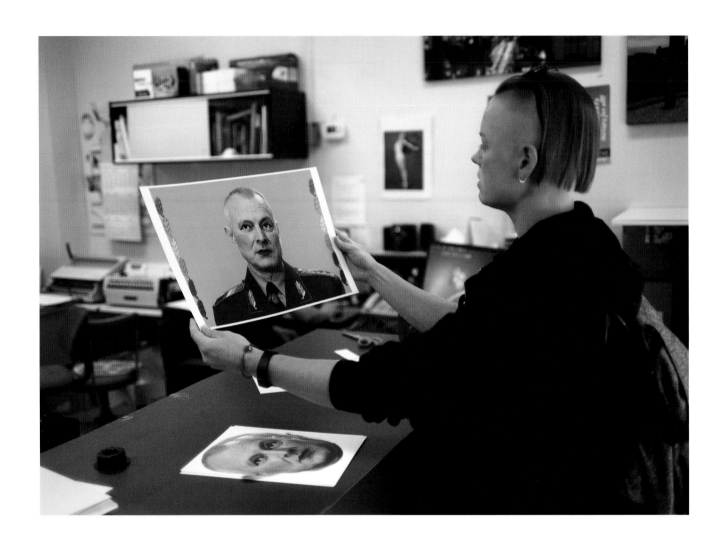

Sveta prepares props mocking a
homophobic Belarusian cabinet
minister during Toronto Pride.

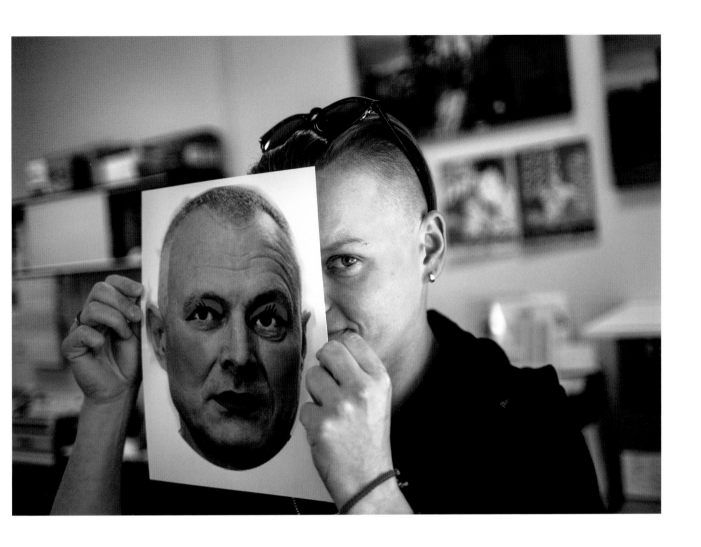

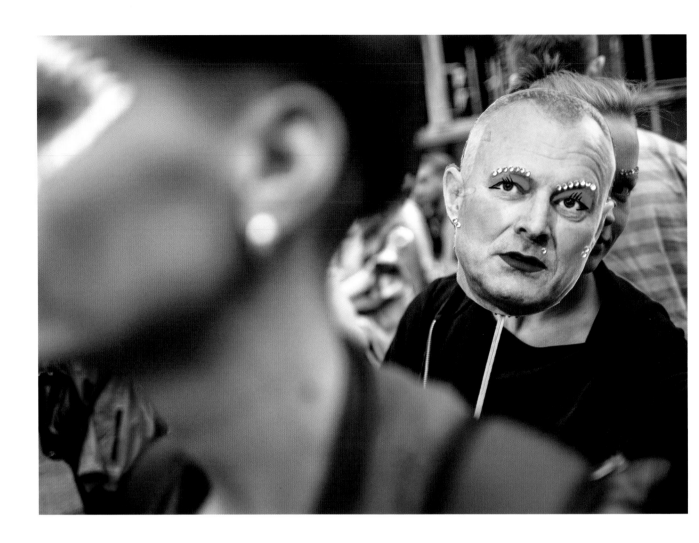

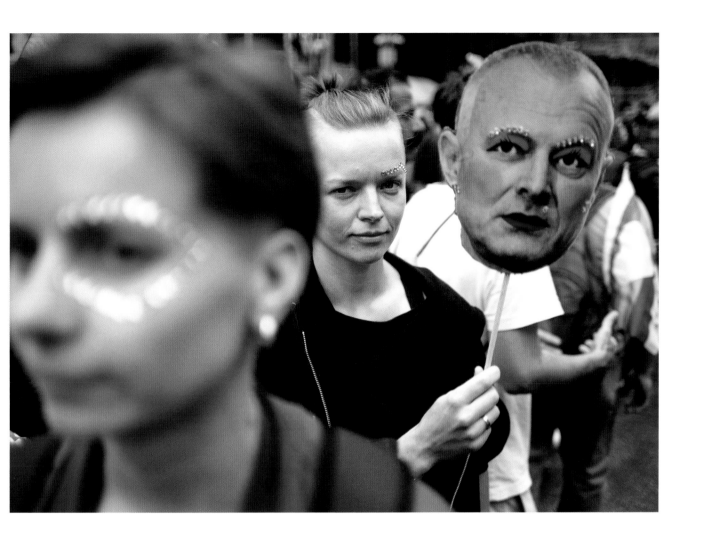

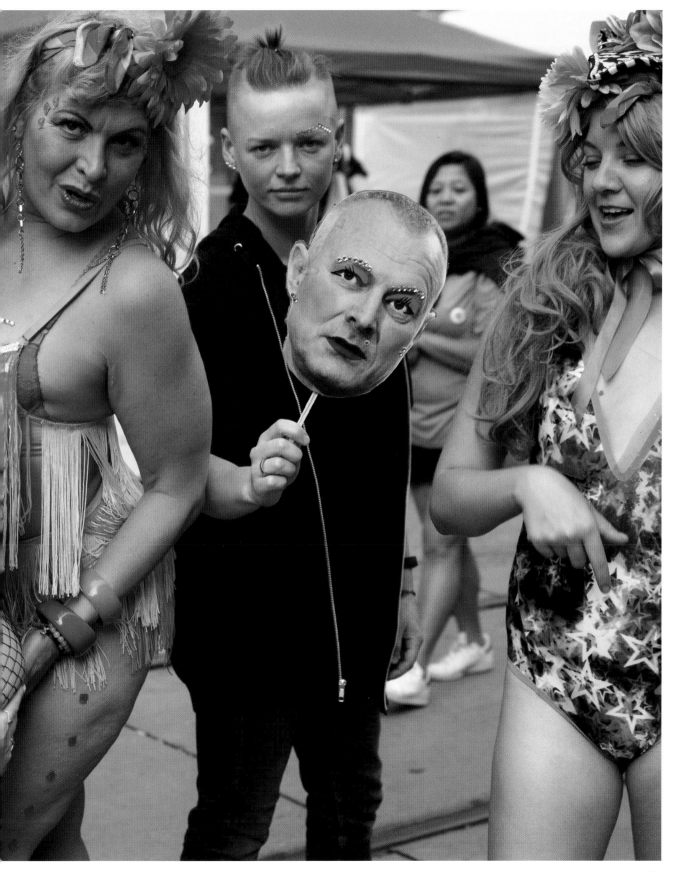

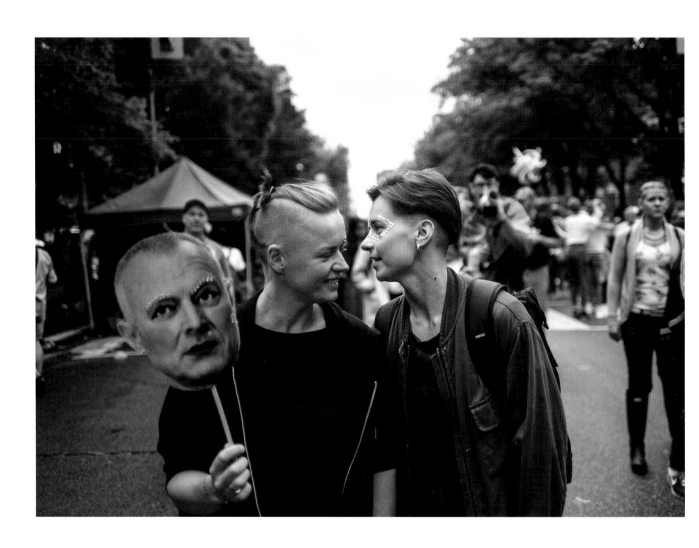

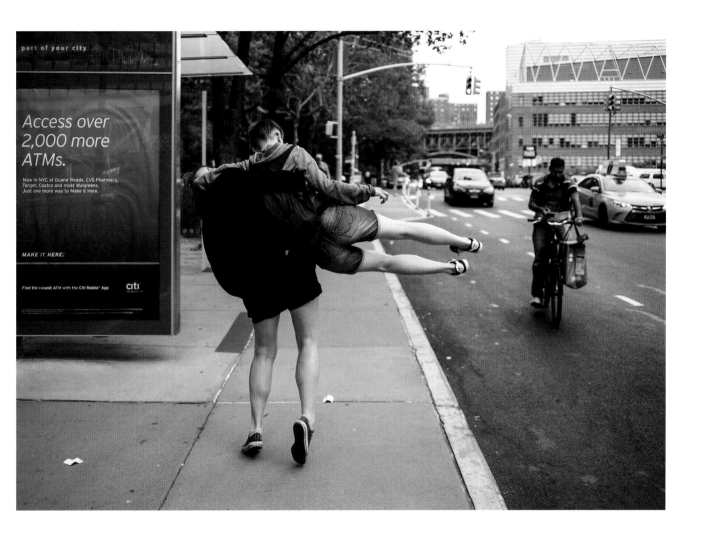

Sveta and Nadya in Kiev.

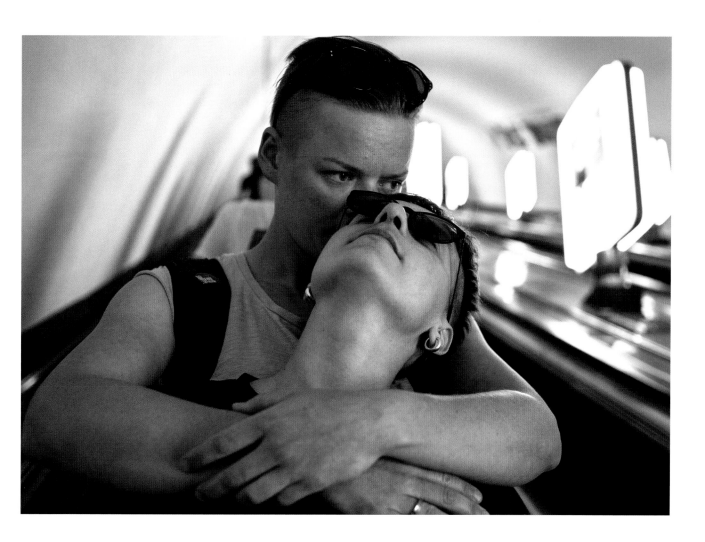

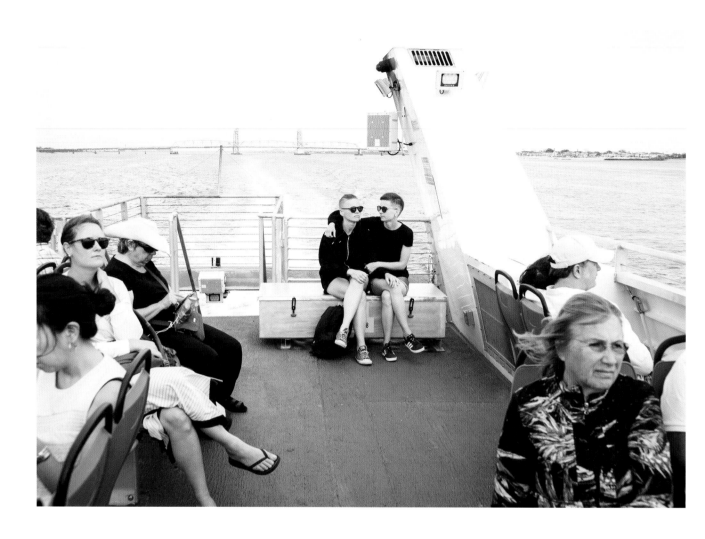

The couple visit New York City. Away from Belarus, the two of them are clearly more relaxed and at ease in public.

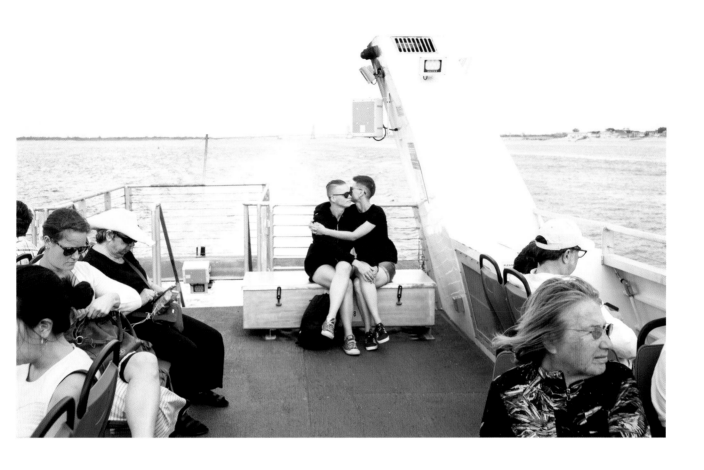

What do you see?

At least once a year, usually twice, the theater makes its actors come out of the underground. They have to go where they live, they have to get outside the bubble of the initiated who come to the garage. They have to make political theater. Because otherwise, what is the Belarus Free Theatre for?

It's usually Kolya and Natasha who conceive the public act of theater, and then they direct actors—especially students—by Skype through the streets of Minsk. They have done interactive public performances on the elections, on disability issues, on law enforcement. At the close of 2018, they decide to stage public performances on LGBT issues.

"Public" hasn't gone with LGBT issues in Belarus. A rare exception occurred in May 2018, when the embassy of the United Kingdom flew a rainbow flag in recognition of International Day Against Homophobia. The Belarusian authorities didn't take to this kindly. The interior ministry posted a rebuke on its website, accusing the British mission of manufacturing issues and reminding the public that most Belarusians espouse traditional, Christian values. In subsequent interviews the minister of the interior told gays and lesbians to stay home and stay quiet.

Somehow staying home and staying quiet doesn't have the same appeal when the minister of the interior thinks that that's what you should be doing. So at the beginning of winter the Belarus Free Theatre stages seven days of actions.

On Day One, they lead a queer tour through the streets of Minsk. They point out that the city has a queer history. Who knew? All the students participate—this is a part of their study—so Vadim, who talked about the "poor gays" and the "fashionable gays" a year and a half ago, is now part of the tour, steering his wheelchair at the front of the group.

On Day Two, they sing. Two actors—a man with an accordion and a woman in vaguely traditional garb—plant themselves in a pedestrian underpath and start performing what sounds like traditional rhymed ditties. She belts out,

How long can they keep pushing
Foreign values onto us?
Beat your wife, your kids, and homos!
That's the done thing now.

Sveta plays girl reporter. She asks passersby what they think of what they are hearing. They like what they are hearing. Good, says Sveta, this is good. They have set a trap. On the one hand, they are apparently disturbing the peace, rupturing Minsk's normal preternatural quiet. On the other hand, they are singing that the gays should stay put and not stick their noses out—and who can object to that?

Eventually, a couple of policemen come and say, "There've been complaints."

"What complaints?"

"People are complaining."

"What could they possibly be complaining about?" Masha, the singer, shouts. "I am singing homophobic ditties! Can anyone be objecting against homophobia?"

The cops are stumped. They go back to get someone more senior. Masha is on the verge of tears: she wishes the argument that no one can possibly oppose homophobia weren't so obviously correct.

Still, they wrap up in order to avoid arrest.

The next day three actors put on police uniforms with rainbow epaulettes. They walk around the city introducing themselves as LGBT MVD—MVD is the police— and demand that citizens "present their smiles." Citizens do. There is even a dance number or two. Then they are detained.

The week ends with an action called "Invisibility."

A woman stands in a public square, wearing a hooded jumpsuit. She unzips it to expose a t-shirt with a rainbow flag on it. Four men are goose-stepping in a circle in front of her. One stops to zip her up, but as soon as he has stepped off, she unzips the jumpsuit and lowers it to her waist. The next enforcer pulls it back up on her, and next she pulls it further down. And so, against all odds, over time, with disproportionate effort, she gets rid of the jumpsuit. So that by the end of the action, she stands there in the square, wearing her rainbow-flag t-shirt and the jumpsuit is lying in the dirty snow on the ground in front of her.

By the end of the week, three members of the Belarus Free Theatre troupe are under arrest. ■

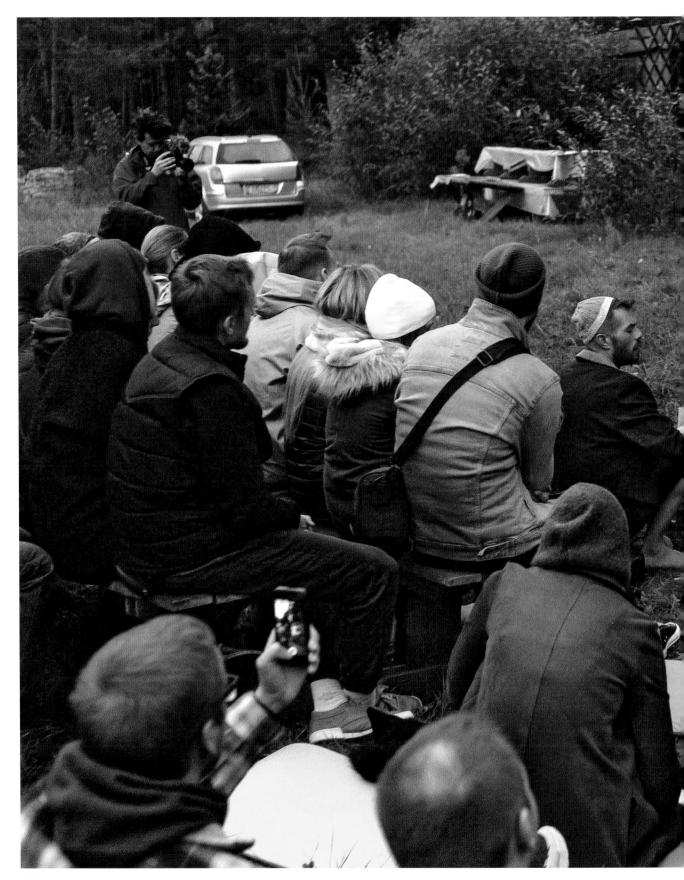

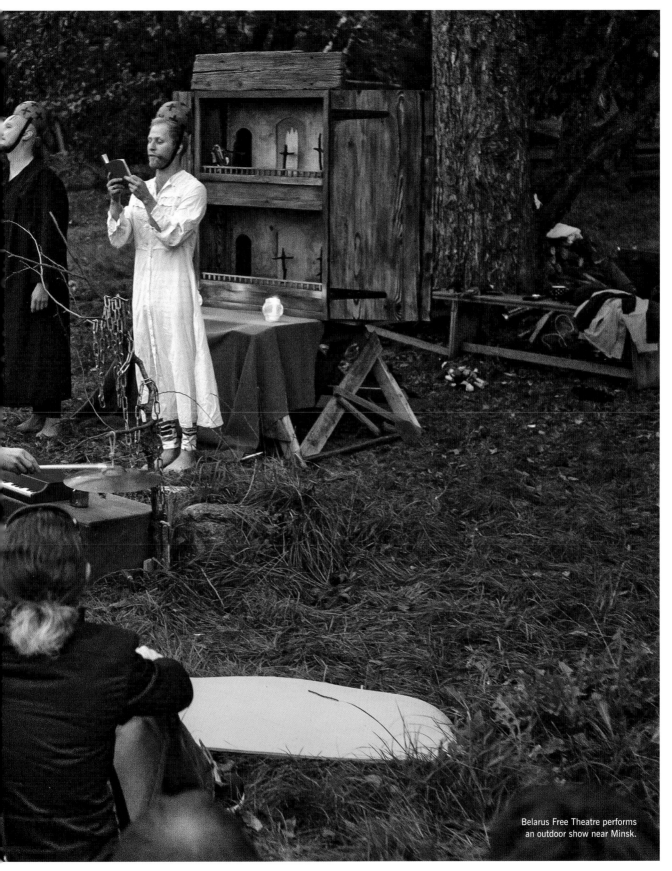

Belarus Free Theatre performs an outdoor show near Minsk.

Nadya and Sveta take reservations for the evening's performance at a secret location in Minsk.

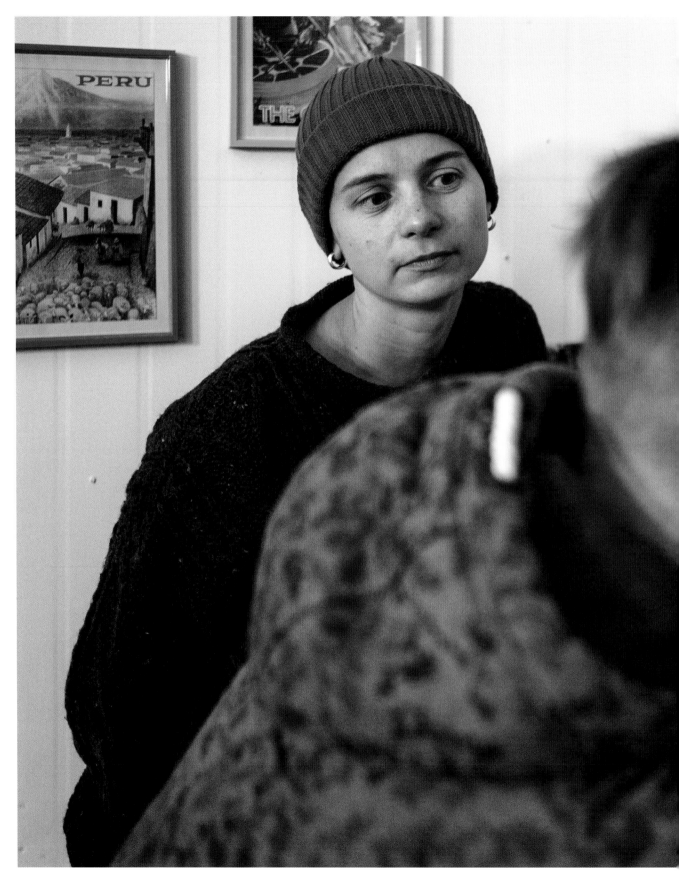

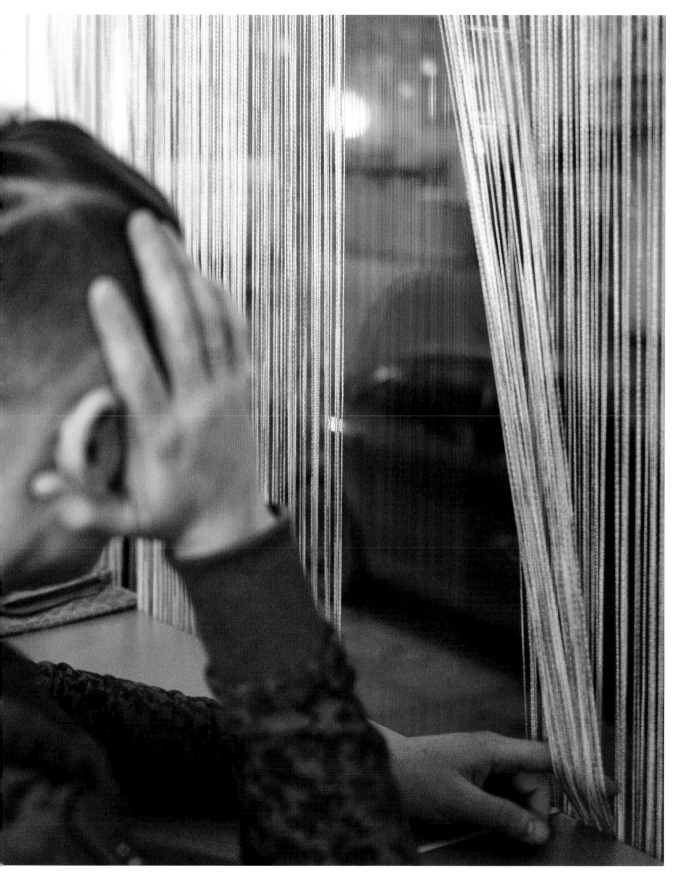

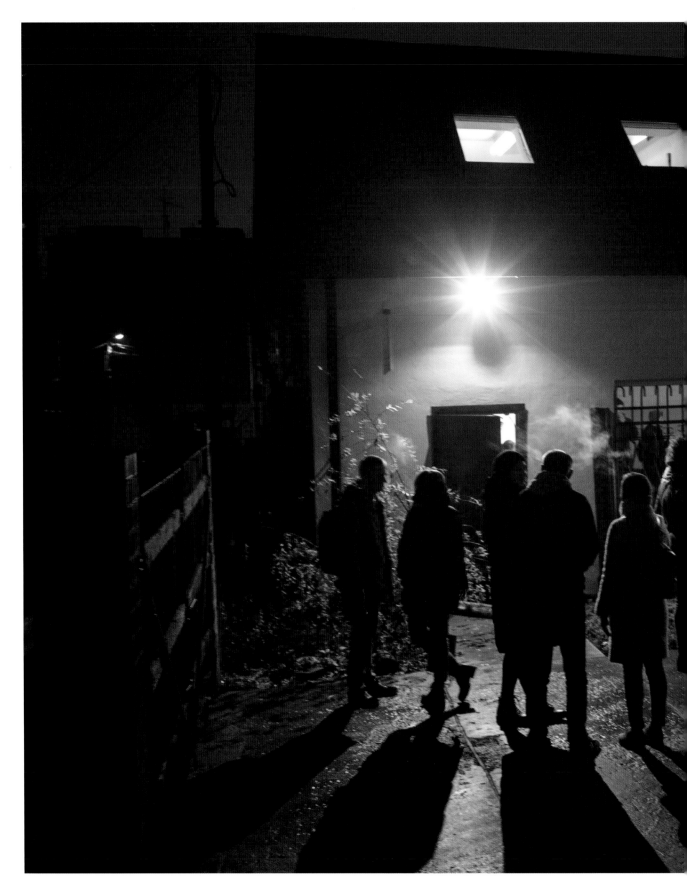

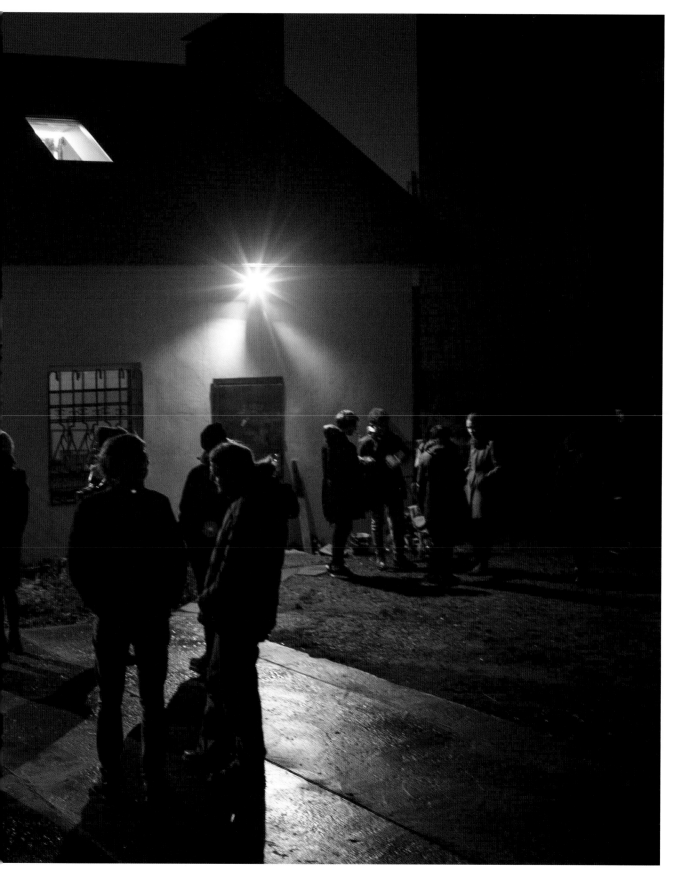

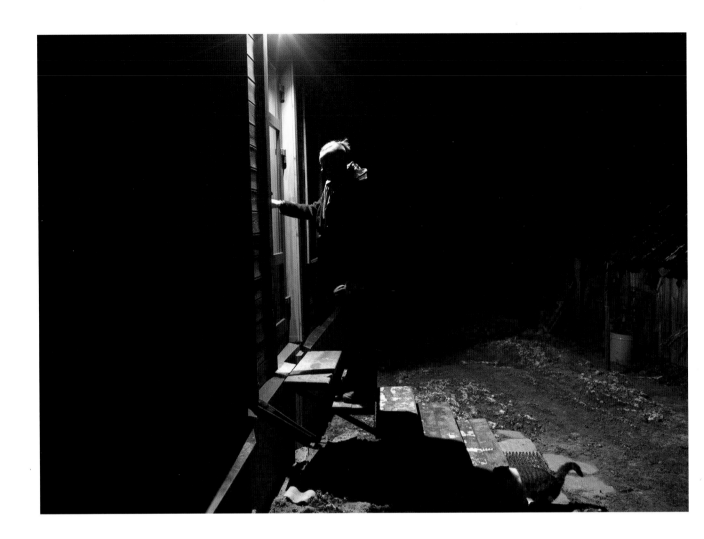

On nights when the theater
troupe performs, Nadya
and Sveta do not get
home until after dark.

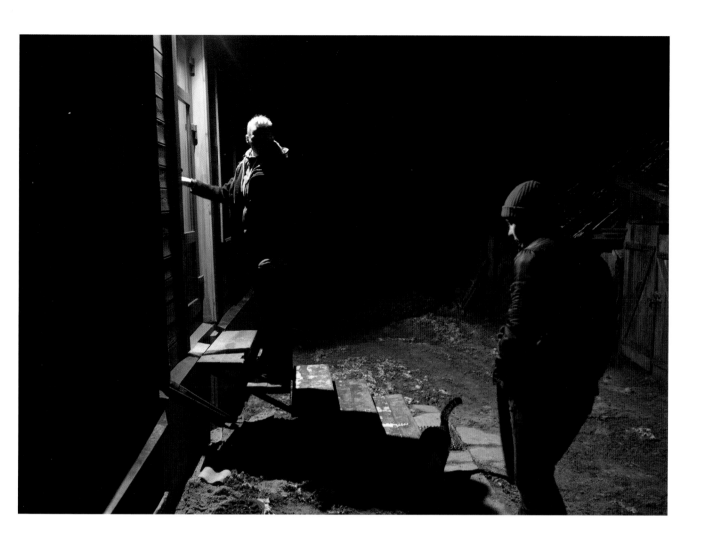

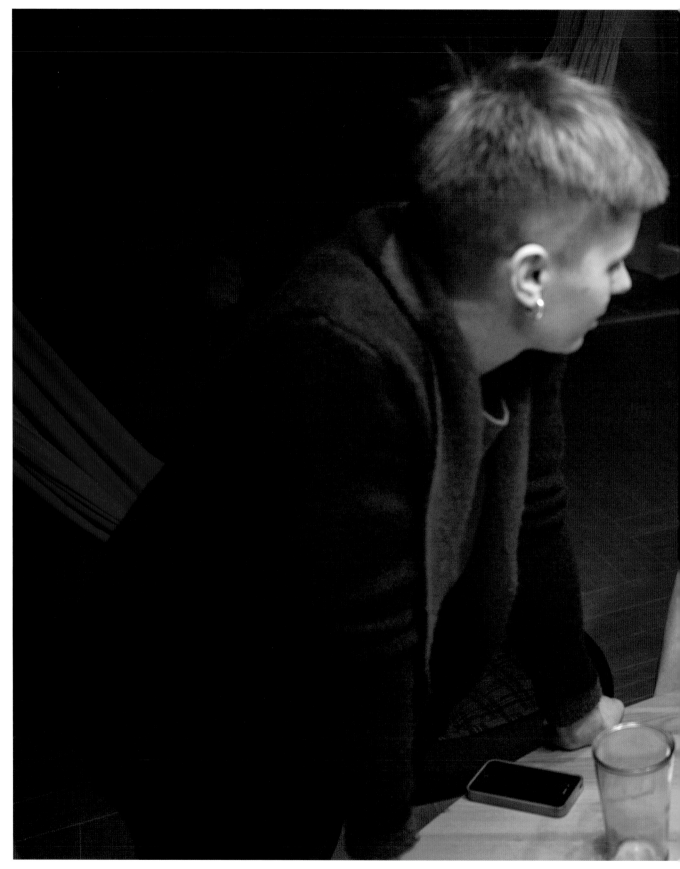

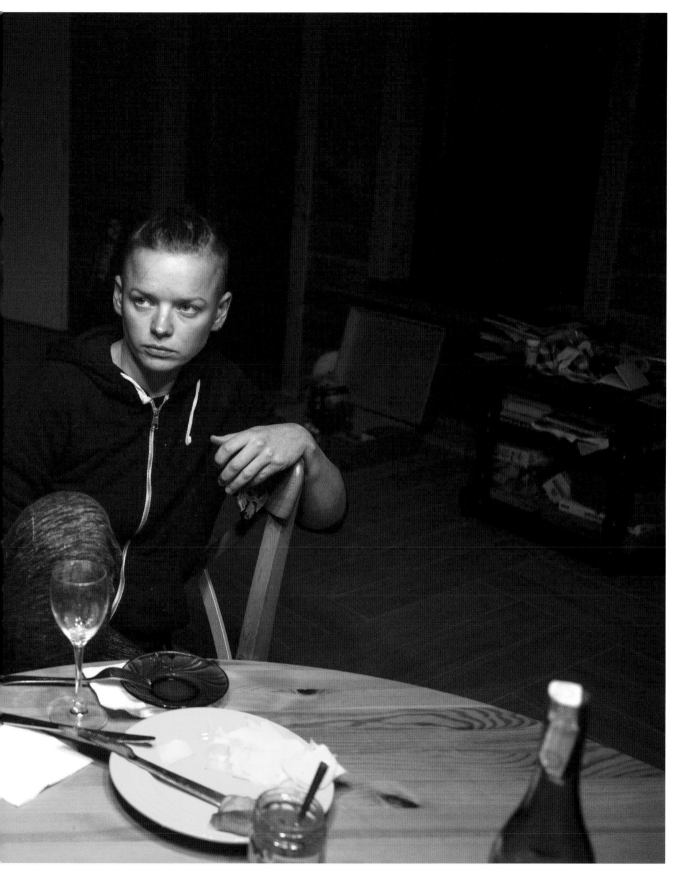

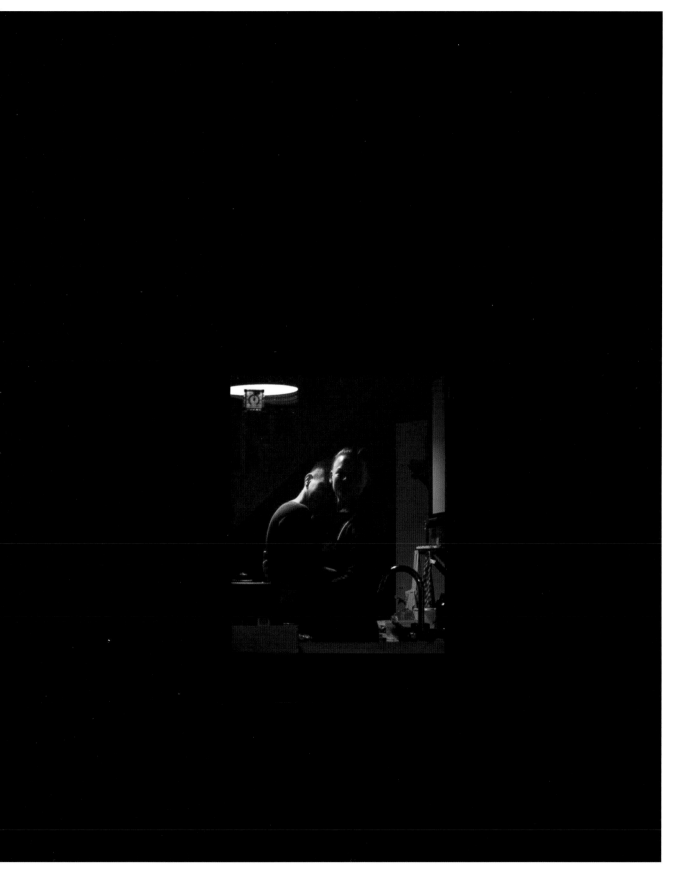

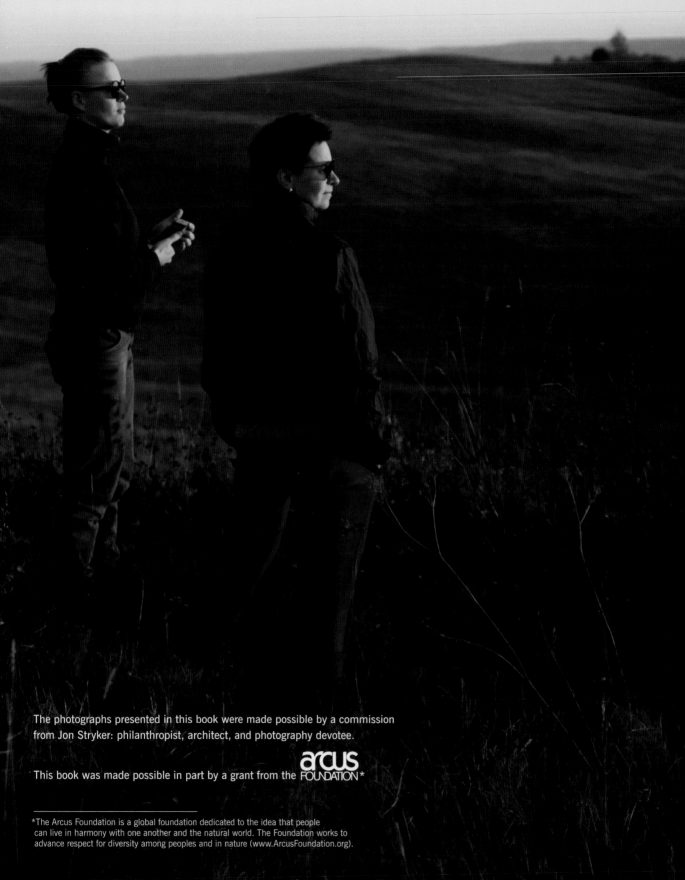

The photographs presented in this book were made possible by a commission
from Jon Stryker: philanthropist, architect, and photography devotee.

This book was made possible in part by a grant from the arcus FOUNDATION*

*The Arcus Foundation is a global foundation dedicated to the idea that people
can live in harmony with one another and the natural world. The Foundation works to
advance respect for diversity among peoples and in nature (www.ArcusFoundation.org).